The Basics of Artistic Drawing

THE COMPLETE COURSE ON PAINTING AND DRAWING

The Basics of Artistic Drawing

BARRON'S

English text © Copyright 1994 by Barron's Educational Series, Inc.
Original title of the book in Spanish is
"Las Bases del Dibujo Artistico"
© Copyright 1992 by Parramón Ediciones, S.A.
Published by Parramón Ediciones, S.A., Barcelona, Spain
First edition, January 1992

Author: Parramón Ediciones Editorial Team
Illustrators: Parramón Ediciones Editorial Team

All inquiries should be addressed to:
Barron's Educational Series, Inc.
250 Wireless Boulevard
Hauppauge, New York 11788

Library of Congress Catalog Card No. 93-20813

International Standard Book No. 0-8120-1929-6

Library of Congress Cataloging-in-Publication Data

The Basics of artistic drawing.
 p. cm.—(The Complete course on drawing and painting)
 Includes index.
 ISBN 0-8120-1929-6
 1. Drawing—Technique. I. Barron's Educational Series,
Inc. II. Series.
NC730.B316 1994
741.2—dc20 93-20813
 CIP

Printed in Spain

56789 9960 987

Contents

Introduction

Congratulations—you have decided to learn to draw and paint! I congratulate you because your decision will introduce you to the wonderful adventure of art, to the pleasures of painting, drawing, creating—of living a more intense life, which is synonymous with living a happier life.

I also congratulate you for choosing this method, a complete course directed by famous artists who encourage an active approach—*nothing is put into words if it can be explained through pictures*. There are dozens of practical exercises that allow you to discover and to practice the methods and techniques of drawing and painting, from lead pencils to oils, from watercolor landscapes to seascapes in gouache and oils.

I truly believe that, through this course, you will learn the fundamentals of drawing and painting: The choice and composition of a theme; making an outline sketch and using perspective; the theory and practice of chiaroscuro to produce effects of light and shade, tonal contrasts, and "atmosphere"; and the theory of color and chromatic contrasts through exploring different ranges and harmonization of color in a picture. Of course, all this will be introduced step-by-step, through practical exercises as well as lessons in theory. For instance, to learn about color you will begin by using only two. This will help you to get to know the medium or method (watercolors, for example) before having to worry about mixes and nuances of color. The next step will be to use the three primary colors—cadmium yellow, alizarin crimson, and Prussian blue—to produce any natural color.

We will work together for some time; we intend to explain how the artist uses the means available to him (his paints, brushes, and paper), how he interprets the forms and colors of nature, using his artistic ability and his creative imagination. We will try to teach you to draw and paint intelligently, bearing in mind that, as the teacher Jean Guitton put it, "You can't teach intelligence, but you can show someone which way to look so that intelligence might come and pay a visit."

Between each line and brushstroke we will try to share with you what we professional artists think and feel: "The fire that consumes you while you are painting," as Tennessee Williams wrote; and the sensation, after a painting is finished, "of belonging to something, something great and noble."

On the subject of "finishing" a painting, we have Picasso's famous phrase: "A finished painting is a dead painting," and Cézanne's equally famous cry of despair—"Will I never, ever reach the end?"—when he felt he would never achieve the aims he set for himself. But Cézanne was a man of extraordinary genius; one of his friends described him as "terrible, deluded, like a wild animal." He was also a humble genius. In August 1906, a month and a half before his death, he wrote to his friend Emile Bernard: "I am continuing to study the nature all around me and I think I am making a little progress. I wish you were here, because I feel very lonely. I am old and sick. I have sworn I will die painting."

This was Cézanne. This is the intense, vital, and transcendental world of the artist and painter. Congratulations—you have entered that fascinating world!

José M. Parramón

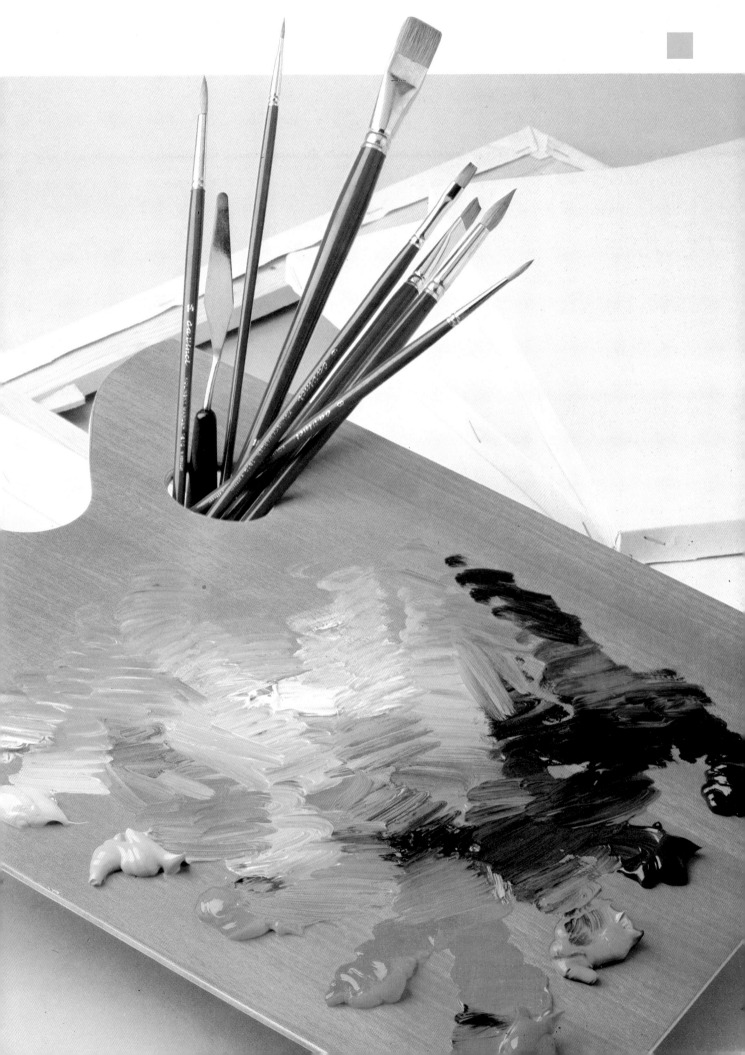

Artists, teachers, and consultants on the course

José María Parramón Vilasaló, director of this course, is a very well-known artist in Spain. In the 1960's, he set up a method to teach drawing and painting. He then went on to found the Parramón Institute, approved by the Spanish Department of Education and Science, which had various famous artists on its teaching staff. More than 20,000 students took part in the courses run by the Institute. At the same time, José María was president of the Spanish Association of Graphic Artists and he also began to teach at the Massana School in Barcelona. In the 1970's, he started writing and editing his own books, setting up Parramón Ediciones, S.A., and devising the "Learn by Doing" series on drawing and painting, which has been translated into more than eleven languages.

José María Parramón says: " I began to paint seriously when I was nineteen years old, after winning the Youth Prize organized by the prestigious Sala Dalmau in Barcelona. And after having several exhibitions I began to write, to paint, and to teach, gaining the experience and knowledge that I hope qualify me to direct this course."

Miquel Ferrón Geis, born in Barcelona in 1948, is one of the most brilliant contemporary artists. An established professional in the majority of drawing and painting techniques, he gained a National Prize in drawing while studying at the School of Arts and Crafts. He regularly collaborates with Parramón on his extensive and effective teaching projects.

Ferrón is a teacher at the Massana School in Barcelona, a prestigious institution founded at the beginning of the century and attended by many famous artists, including Picasso himself.

You would have to see Miquel Ferrón in a class of more than thirty students, encouraging them to darken that shadow a little, or to explore those tones in a little more depth, to appreciate that this great professional was born to paint and to teach painting to those who want to learn about this fascinating world.

In the pages of this book, Miquel Ferrón shares with us his artistic wisdom, his years of experience, and his command of many different media, demonstrated through the pictures he has created especially for everyone who, like you, decides to read and to "live" the chapters of this book and the others in the series.

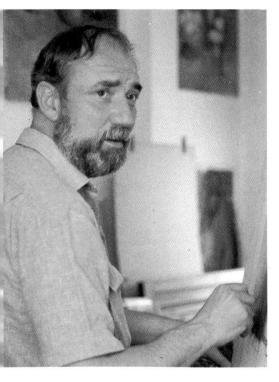
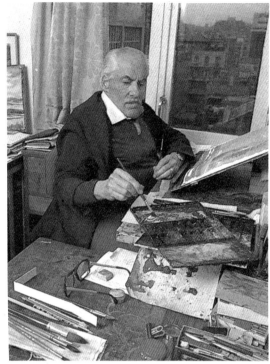

Francesc Crespo, whose work as a consultant to the production team on this course has been invaluable, is a professional with a long track record. He has had more than twenty exhibitions in Spain, Italy, and other countries; he has won various prizes for drawing and painting and many of his pictures are hanging in galleries and museums.

A Doctor of Fine Arts and, until recently, vice-president and professor of the Fine Arts Faculty at the University of Barcelona, Crespo, says: "This course goes into the methods, styles, and techniques in a lively way, using plain language. I consider that it is practical, for example, to tell a student that the individual parts of a picture must be subordinate to the whole; if you are drawing a figure study, you should not linger too long over the hand, forgetting the rest of the body. You have to see things as a whole, paying attention to the rules, but without allowing them to hamper the natural development of your creativity. I am happy to contribute whatever support and expertise I have to offer to the successful production of this course."

Guillermo Fresquet Bardin, one of the most acclaimed Spanish watercolorists, has also given us the benefit of his experience to ensure that the lessons we offer are effective and practical.

Fresquet carried out his early studies at the School of Fine Art in Barcelona. He soon decided to concentrate on watercolors and 1946 saw the first of a long series of exhibitions which, over the years, have taken place in Madrid, Paris, and other European capitals. Winner of numerous medals and prizes, his work has been acknowledged through many renowned international salons and exhibitions.

Finally, we must not forget to mention Juan Sabater, Muntsa Calvó, Ester Serra, and Pere Món, all great artists, who have contributed their enthusiasm and expertise to our project. Their individual ways of looking at painting have undoubtedly enriched the content of this course and given it a truly extraordinary breadth of vision.

Methodology of the course

This is a painting and drawing course with a methodology and a study program that can be summed up in three words: **Practical, complete** and **instructive.**

It is a practical course because it has been devised and edited by artists who know about painting and teaching painting; artists who, although aware of the value of theoretical teaching, also believe that the most effective method of learning to paint and draw is by doing it.

That is why most of the extensive information contained in our course is presented visually. More than words, the novice needs facts: *What to do* and *how to do it*. Hundreds of photographs, drawings, and paintings form the basis of our teaching method. They offer step-by-step, practical information on the use of materials and the application of drawing and painting techniques with a view to creating lively, attractive sketches and, of course, beautifully finished paintings.

It is a complete course because the artists participating in its production nearly all come from the field of teaching and are very knowledgeable about drawing techniques (lead pencil, charcoal, sanguine crayons, chalks, pen and ink, colored pencils, marker pens). They are also expert at teaching traditional and modern pictorial techniques (wax crayons, pastels, watercolors, tempera, oils, acrylics). It is a complete course because all the fundamentals of drawing and painting are examined closely and consolidated throughout. Students really learn to paint from nature, to create a picture from its conception to its final touches, and learn to compose and construct a picture and to harmonize tones and colors. They also learn how to deal with perspective, anatomy, the laws of composition, the theory of color, and so on.

It is an instructive course because it is the result of teamwork, of teacher, artist, and editor, who have always tried to remember the person sitting before them—you, the student. We have tried to make sure that as you look, see, and read, you have the sensation that we as a team are beside you, helping you to draw and paint, to develop the creative potential that is undoubtedly inside you, to crystalize it, to make it a reality—something possible when the desire to teach and the will to learn coincide.

If, as the dictionary suggests, didactics is the art and science of teaching, then our course is undoubtedly didactic, as it attempts to create a new process for teaching the practicalities of drawing and painting.

José María Parramón
Director of the course

Here are some of the works produced by four of the artists who collaborated in this course, giving us the benefit of their great experience and expertise.

Above. *Oil painting by José María Parramón, photographed during its initial stages and, on the right, when complete.*

Center. *A nude by Francesc Crespo, in charcoal, sanguine crayon, and white pastel. We see it as the artist is beginning to work on the chiaroscuro (left) and after it has been completed (right).*

Below left. *Fragment of a seascape by Miquel Ferrón, using watercolor and marker pens. You will have the chance to use this combination of techniques, under the guidance of the same artist.*

Below right. *Watercolor painted from nature by Guillermo Fresquet, one of our collaborators.*

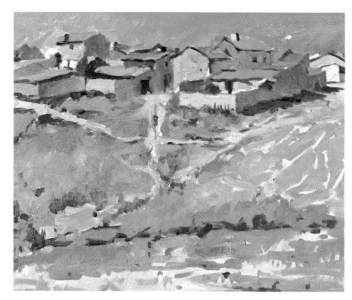

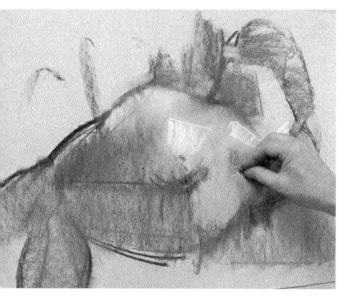

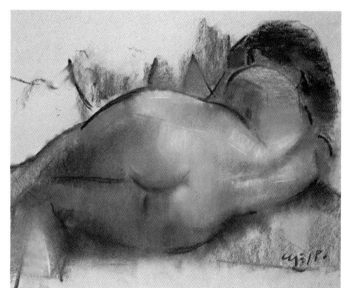

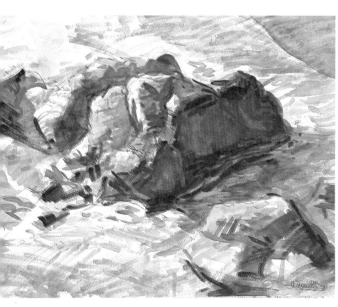

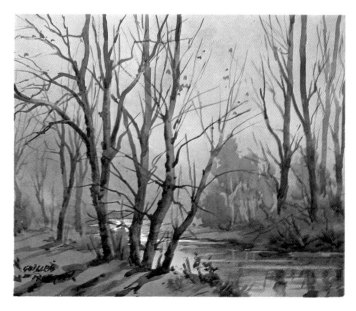

Materials, tools, and techniques of drawing

Ingres, the great French painter, once said: "How you paint depends on how you draw." We could expand this quotation by adding that "knowing how to paint and draw depends on knowing the materials best suited to each technique."

We will look at the pencil, for example, at the different types, at their respective hardnesses, at the line produced by each, and at the various makes on the market. We will also look at types of paper—some smooth, some heavily textured—papers of different weights, different makes and quality, and at the results obtained from each type.

Equally, we will investigate practical and interesting aspects such as using the eraser, prolonging the life of your pencils, and the various ways of sharpening them. As you will see immediately, we will not just give you bald facts about concrete makes, but also simple, useful, practical exercises to underscore the information contained in the text. So, for example, if the line drawn by a particular pencil is described, an illustration of this line will be included.

We suggest that you do not just look at these illustrations, but also that you learn to do what you see in them! Try out the tonal possibilities of the 2B pencil and compare them with those of the HB; learn to differentiate between paper textures through practical experience: Look at them, draw on them, until you can tell them apart by touching them.

Get used to the idea that it is not always important to stick rigidly to our guidelines. As you improve through imitating our examples, you should also experiment on your own with materials and techniques, so that you can envisage with greater accuracy and confidence the effect you can expect from each when adapting them to your own projects. After all, one of the most exciting things about learning how to draw and paint is the constant discovery of new methods and new tricks of the trade, which, little by little, enrich your creative powers.

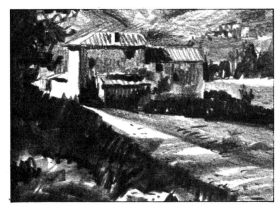

Using a hard pencil, how-ever hard you press on the paper, you will never manage more than a mid tone of gray. The hard lead is not easily worn away and can never pro-duce the broad strokes sometimes required in an artistic drawing. However, hard and very hard pencils are excellent for line and technical drawing or, occasionally, for works demanding an extreme softness of tone.

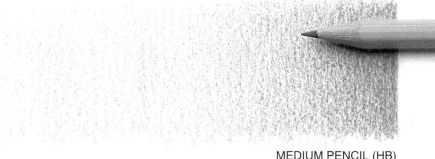

MEDIUM PENCIL (HB)

What tools do I need for drawing?

It is a question we have all asked at some stage and, perhaps, one you are asking at this very moment. If we were to limit ourselves to the minimum, we could say that a normal No. 2 pencil—or a good-quality HB, paper, an eraser, and a clip-board or piece of backing board as a support are all we need to start drawing. Of course, going on from this list, we could add anything our personal tastes or needs demand: A harder or softer pencil, white or tinted paper, different types of pencils (lead, charcoal, san-guine, etc.). Every new possibility is a way of broadening your potential for expression and developing a style of your own. However, none of these considerations affects the basic fact that all you need for drawing are a pencil and a piece of paper. And because we have referred already to normal pencils and superior quality pencils, take note that:

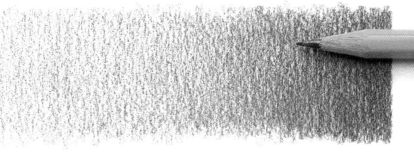

MEDIUM PENCIL (2B)

Pencils classified by numbers are normal pencils, in everyday use.
Superior quality drawing pencils are catego-rized by letters.

In the illustration on the right you can see that the difference between a hard and a soft pencil stroke is really significant. The soft pen-cil allows a wide range of grays and (the very soft ones) for intense blacks. Soft pencils are useful for gradation of tone ranging from pale gray to almost jet black.

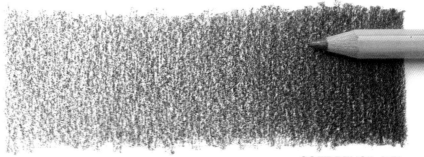

SOFT PENCIL (6B)

PRINCIPAL MANUFACTURERS OF SUPERIOR QUALITY PENCILS		
Country Of Origin	**Manufacturer**	**Make**
France	Conté	Castell
Germany	A.W. Faber	Carbonit
Germany	J. S. Staedtler	Negro
Czechoslovakia	Koh-i-noor	
Switzerland	Caran D'Ache	
United Kingdom	Cumberland	
United States	Faber	Mongol

The "koh-i-noor" type offers a wide range of pencils for artistic and technical use. So do the other makes mentioned. Naturally, you will not need the whole range to produce good drawings but to be able to choose the right grade for each particular drawing is an obvious advantage.

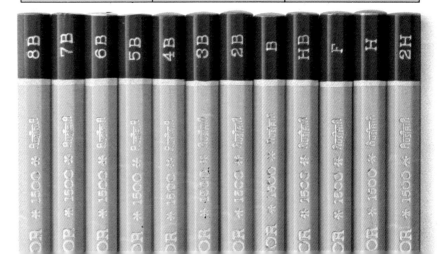

Pencils to suit all tastes

In this landscape, an H pencil has been used for the lightest areas of the background and the building.

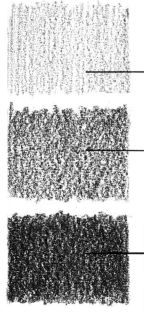

With a 2B pencil (perhaps the grade most used by the professional) the medium tones of the drawing have been established.

For the foreground blacks and interior spaces, an 8B pencil was used. These blacks emphasize depth.

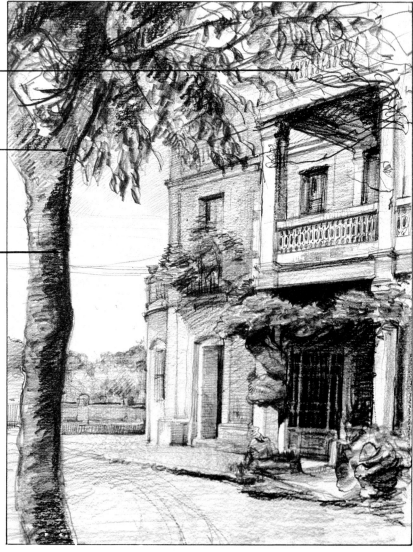

Graphite is a mineral discovered in 1560 in the mines of Cumberland, England. Mixed with greater or lesser quantities of clay, it is the material that makes up pencil lead. Today, manufacturers offer many different grades and qualities of pencils:

Superior quality pencils. Soft pencils, indicated with a B, are best for artistic drawing (B, 2B, 6B, 8B, and so forth). Hard pencils are recommended for technical drawing and are indicated with the letter H (H, 2H, 5H, 7H, and the like). HB and F lie between hard and soft.

Classroom-type pencils. Numbers 1 and 2 correspond to 2B and HB in the softer range; 3 and 4 are the equivalents of H and 3H in the harder range.

In all, there are nineteen different grades of superior quality pencil and just four classroom-type pencils. Individual pencil leads are very useful but must be used with a clutch pencil; these are also available in different grades and qualities. We recommend the 2B pencil for general use. This grade is able to produce a fairly dark gray but can also produce paler, fine lines. It is also useful to have a 4B and an 8B for quick sketches and filling in dark areas. Really, any soft pencil can offer a wide tonal range and which one to choose depends on the subject and the artist's personal tastes.

KOH-I-NOOR PENCILS Grade table			
Soft grade	**Medium grade**	**Hard grade**	**Extra-hard grade**
(Artists')	(Everyday use)	(Technical)	
7B	2B=1	H=3	6H
6B	B	2H	7H
5B	HB=2	3H=4	8H
4B	F	4H	9H
3B		5H	

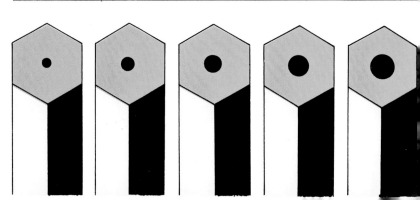

The thickness of the lead relates to its grade. The softer the pencil, the thicker the lead will be.

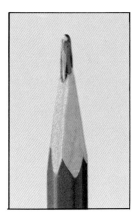

Left. Point obtained with a pencil sharpener. Compare this with the point produced using a scalpel or razor blade (right).

Below. When sharpening with a scalpel, make lots of small cutting movements—and take care! The scalpel is a dangerous tool.

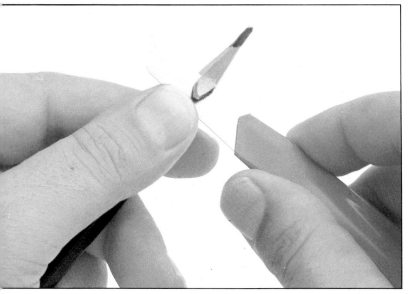

How to sharpen a pencil

It is important to sharpen your pencil correctly, though it may not seem so to the beginner. You must try not to break the lead, but to shape it into a smoothly tapering point that will be a delight to work with.

These days, many professionals refuse to use the traditional sharpener, which gives the pencil a point that is short and impractical. A razor blade, or more particularly a scalpel, is much more effective (see the illustration on the left). Make firm, deliberate movements, paring off fine shavings of wood (cedar is the best kind). To sharpen the point, there is nothing more useful than a specially designed metal scraper; but beware of sharpening the point too much because it will break easily.

Pencil holders and clutch pencils

Drawing with a pencil that is too short is an awkward business and hinders the creation of confident, loose strokes. To lengthen the life of the pencil there is an ancient but extremely useful device known as the pencil holder. This allows you to enjoy your friend of wood and graphite to the limit of its useful life and to save money in the bargain.

Metal clutch pencils appeared some years ago as a practical alternative to the traditional pencil. These days, the range of leads of different grades and thicknesses on the market is very wide indeed. Naturally, for the thicker, softer leads, wider clutch pencils are available.

We are going to allow ourselves to be a little traditional and to say that, although clutch pencils can produce the same results as ordinary pencils and in spite of their practicality (you don't need to sharpen them), we prefer the old-fashioned wooden variety for artistic drawing. They are warmer to the touch, you can create your own point and, finally, they are more enjoyable to use.

It is important to have a big container for your pencils, always storing them with their leads pointing upright.

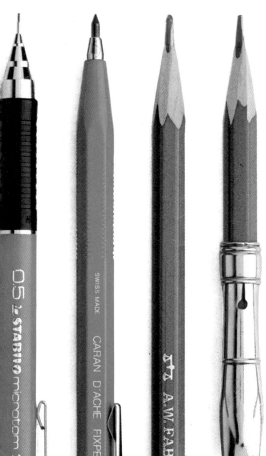

From left to right. A clutch pencil for hard leads, another for soft leads, a normal pencil and a pencil in a holder to make it last longer. There are many different makes of clutch pencils on the market for different lead thicknesses.

The eraser

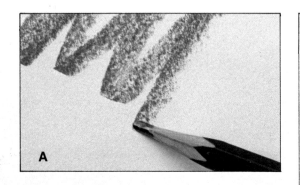

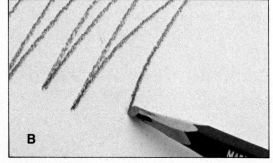

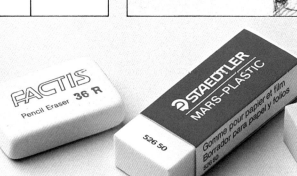

Above. The drawing on the right has been produced using different types of pencil strokes: Type A, with the lead applied flat, cut in a wedge shape for wide strokes and type B, with the same shaped lead turned on its back, for sharp outlines.

As you can see from the illustrations above, the strokes a graphite pencil can produce vary enormously.

With the lead sharpened to a wedge shape, for example, we can produce wide strokes by applying it flat against the paper, and fine strokes by turning it on its back, as seen in diagram B. But mistakes will happen, so we will need, alongside the pencil, a good eraser for rubbing out, as well as for other purposes.

It should be clearly stated at this point that ideally the eraser should be used only for opening up highlights, for sharpening outlines, and so on. It is better to start a new drawing than to damage the surface of the paper with a lot of rubbing. The most suitable eraser for use with the lead pencil is the soft, bread crumb eraser and the plastic or rubber eraser that is denser but equally effective. The modern kneadable or putty eraser should also be mentioned; it can be molded into any shape you require.

Drawing paper

PRINCIPAL MANUFACTURERS OF QUALITY PAPERS	
Arches	France
Canson & Montgolfier	France
Daler	United Kingdom
Fabriano	Italy
Grumbacher	United States
Guarro	Spain
RWS	United States
Schoeller Parole	Germany
Whatman	United Kingdom
Winsor & Newton	United Kingdom

Above. A list of some of the best professional papers on the market.
***Below.** Drawing paper —especially watercolor paper—comes in pads that are sometimes gummed on all four sides.*

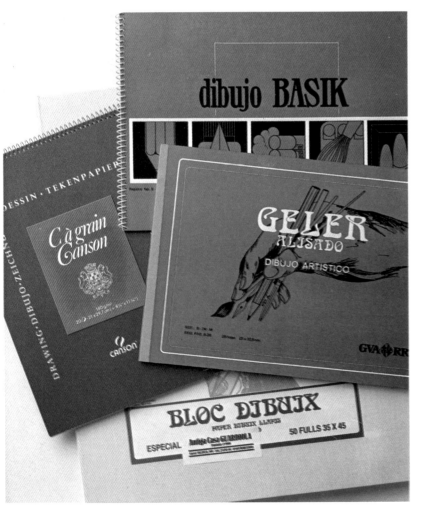

Any paper, more or less, with the exception of plastic and metallic varieties, is suitable for drawing. Great artists have created great works on packing paper. However, we should distinguish between normal, everyday types of paper made from wood pulp using mechanical processes for mass production, and the high-quality papers made from textile fiber (high rag content), using more traditional methods with much greater quality control. These are expensive, so the same manufacturers often produce medium-quality papers as well. Let's look at some of the finishes and textures of various types of paper.

Smooth or glossy paper. Hot-pressed, this has almost no "grain," or texture. It is used for drawing with pen and ink and also with a lead pencil, in both cases providing smooth gradations and shading.

Fine-textured paper. This also produces velvet-smooth shading and gradations and is perfect for drawing in soft graphite pencil, wax crayons, or colored pencils.

Medium-textured paper. Used for pastels, sanguine crayons, chalks and, to a limited extent, watercolors.

Ingres paper. White or colored, this is one of the most traditional papers on the market. Its special texture is clearly visible if held against the light; it is the standard paper for drawing with charcoal, sanguine crayons, or pastels.

Cartridge paper, white or colored. This is a widely used paper with a rough texture on one side and a medium texture on the other. Its texture and sized surface make it a very versatile paper, used with charcoal, sanguine crayons, pastels, chalks, and colored pencils.

Watercolor paper. Various textures and qualities are available, ranging from hot-pressed (fairly smooth) through cold-pressed (semi-rough) to rough. Each is intended for a particular kind of watercolor painting, although all are occasionally used for pencil drawing.

Other papers in less frequent use are rice paper, for instance, which is used for exquisite washes, and various types of coated paper for pen and ink, as well as other flock or cloth-lined papers. You will certainly find something to cater to whatever your particular need might be.

Paper: Appearance, weights, and measurements

Weight and format

Paper is generally sold in reams (500 sheets), and comes in different weights, such as 16, 20, 40, 50, and 90 lb.

As for formats, Fine Art paper comes in various sizes, the most popular being 9 × 12, 11 × 14, 14 × 17, and 19 × 24 in.

Some papers are sold mounted on board and even in rolls. The most normal presentation is in pads of individual sheets. Watercolor pads are sometimes gummed on all four sides. Except for certain heavily textured papers, all watercolor papers are perfectly good for drawing with pencils, charcoal, sanguine crayons, chalks, and pastels.

Good papers are expensive and easily identified. They are stamped or watermarked with the name of the manufacturer in one corner: Arches, Canson, Schoeller and Fabriano and many others do this.

The most frequently used paper

If we had to decide which type of drawing paper is most frequently chosen from all those on the market, we would probably go for the medium-quality, medium-textured cartridge paper that gives excellent results with all types and grades of pencil. It is quite another matter if you are undertaking a specific project or an exhibition of your drawings, in which case it is worth paying the price for high-quality paper of the type best suited to the work in question. Each manufacturer produces different textures and weights within each paper type, including hand-made papers that have the characteristic uneven edges distinguishing them from other papers.

These are some of the best brands of drawing paper, listed in each case with the corresponding manufacturer's trademark. Observe the different textures or grains of each sample.

The pencil *par excellence*

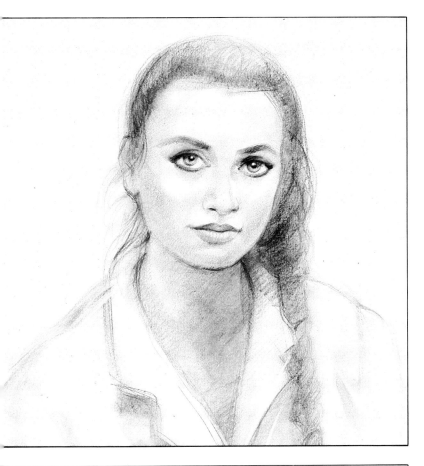

When we ask in a vague sort of way for "a pencil," we assume that we will be given one with a graphite lead and of a medium grade—a No. 2, for example. The graphite or lead pencil is the pencil par excellence and, just as we looked earlier at the most frequently used paper, before starting to look at the art of drawing itself we should refer to the possibilities of the medium of graphite.

Essential to the art of drawing, the lead pencil offers an unlimited range of creative possibilities. From the simplest sketch to the most beautifully studied still-life; landscapes, portraits, nudes—the pencil is usually the medium first used when exploring these areas.

A drawing on smooth paper made with a 2B pencil produces soft, even shading and gradation; the same drawing made using the same pencil but on a medium-grained paper gives a more textured efffect. By blending the pencil strokes with the fingertips, an infinite range of exquisitely subtle gradations can be achieved, especially on very smooth, high-quality paper.

Another effective combination is that of pencil and white chalk on colored paper, such as Ingres paper. In portraits, where the strokes can be blended and gradated, the pencil produces some wonderful results.

Graphite sticks ("all-lead" pencils) are also useful tools. By applying them with flat strokes, you can achieve wide, even areas of shading. The combination of pencil and graphite stick produces some fascinating effects. Try also combining a 2B and an 8B pencil on very smooth paper; play with the white of the paper itself and you will discover some lively contrasts.

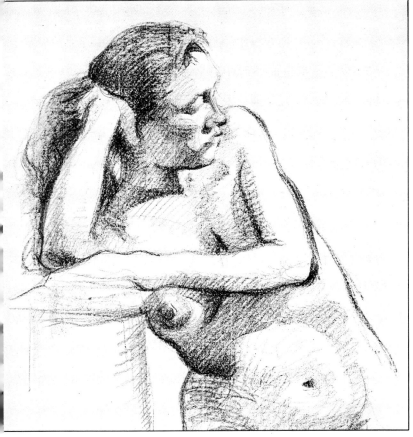

Here are two beautiful examples showing the versatility of the graphite pencil.

Above, *a drawing on very smooth, good-quality paper; some strokes have been softly blended with the fingers.*

Below, *a lively drawing on a medium-grained paper using spontaneous, unblended pencil strokes.*

19

■ Training the hand

You enjoy drawing, but you say that you don't know how, and yet you must have signed your name hundreds of times over the years. We would like to point out that every time you sign your name, you *are* drawing, in a way. The same training that in your childhood taught your hand to produce the wavy, straight, and broken lines that make up your name, is now going to help you begin your apprenticeship in drawing.

You should start by practicing what we might call the ABC's of drawing, until you can produce a series of basic pencil strokes as confidently as if you were writing the letters of the alphabet: Straight lines, circles, parallel lines and cross-hatching, wavy lines, spirals—all of which you will be able to apply later in your artistic creations.

The preliminaries

These may be summed up under the following three points:

• **Sit correctly.** Sit comfortably at an angled drawing table or a board rigged up at an angle on a standard table, so you can see the whole drawing paper at a single glance.

• **Make sure the light is good.** Whether natural or artificial, the light should always come from the left—if you are right-handed, that is. If it does not, disconcerting shadows may fall across your drawing. Your own hand can also create some strange shadows.

• **Hold the pencil properly.** For drawing, the pencil is held a little higher up than for writing. An additional tip: To avoid damp or greasy marks on your drawing, place a piece of paper under your working hand. Remember also that, whenever possible, the area you are working on should be directly in your line of vision to prevent any distortion.

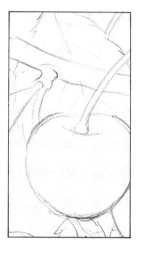
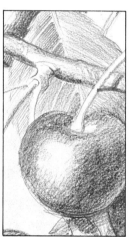
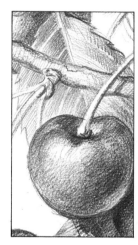

The basic strokes

Diagonal straight lines
These are continuous, uninterrupted strokes, made by moving not only the hand, but the whole arm, across the paper. Trace these lines diagonally, slowly at first, then gradually more rapidly, trying always to keep them the same distance apart. In other words, draw sloping, parallel lines. Practice also drawing lines sloping the other way.

Vertical and horizontal lines
Following the same principle as before, without lifting the pencil from the paper and keeping the same distance between strokes, draw a series of horizontal lines first and then (without turning the paper around) a row of vertical ones, to form an area of cross hatching as even as possible.

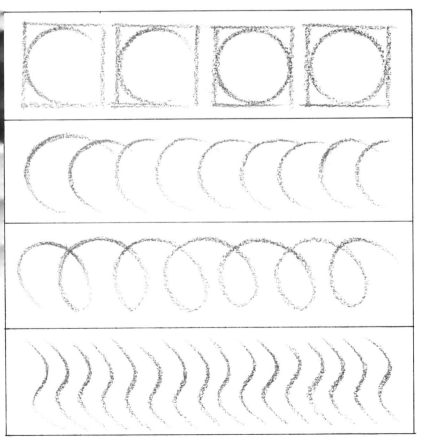

Curves and loops
To start out on curved lines, begin by drawing a row of boxes and trace a circle inside each one. Try to produce these using two firm lines: One to form the left-hand side and the other, the right. When you have mastered this technique, you can start drawing a series of the letter " S " using loops and curves. They should be made in a single stroke, taking care with proportions and harmony of form. Fill up as many sheets of paper as needed to produce the strokes shown on this page without difficulty.

Your pencil strokes should always be continuous and confident, made without any hesitation. Although these are elementary exercises, try to give the different strokes on your paper a sense of proportion and composition.

Shading and gradation

These exercises in shading and gradation should be carried out holding the pencil firmly. First, practice shading with a 2B pencil using diagonal strokes. Try to maintain an even pressure and speed of movement across the paper.

Carry out the same exercise again, but this time using an H pencil, much harder than the 2B. Study the difference between the two pencils when used on the same paper.

Practice vertical gradations using a 6B pencil, one of the softest, and an H, blending them together to highlight the differences more clearly. The H pencil blends in with the gradation where the shading of the 6B pencil becomes less intense.

Finally, produce a vertical gradation using an H pencil, spreading outwards from the center and reinforced in the central area with a 6B. These four exercises have all been carried out on a fine-textured paper.

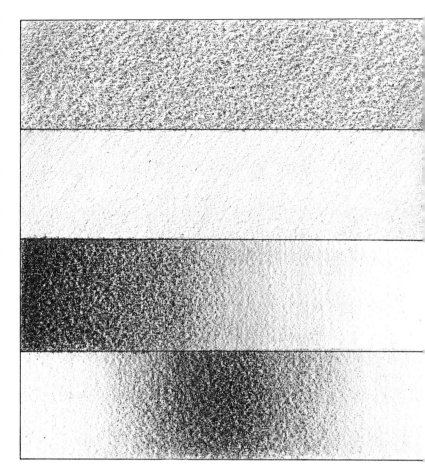

And now for something a little more interesting as a complement to the previous exercises: The same shading and gradations as above, produced inside different shapes. First, draw squares, rectangles, or whatever shape you like, and then fill them in using shading or gradation. This will teach you how to work within predetermined dimensions.

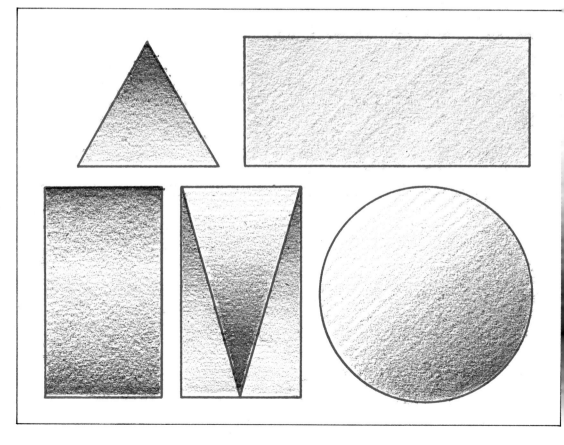

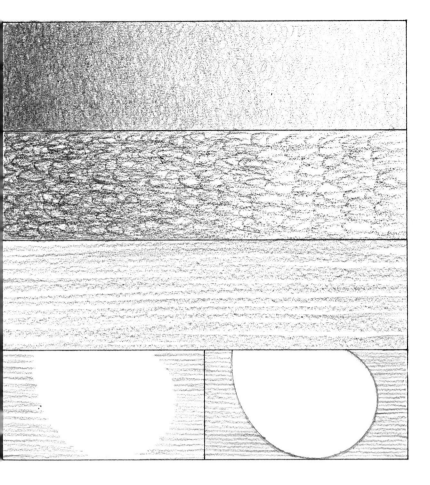

Gradation using circular strokes

Using a 2B pencil for dark areas and then an HB pencil for the lighter parts, draw a gradation using small, rapid, circular strokes. The wrist and arm should move simultaneously.

Gradation using elongated curves

Cover a pre-determined area with a gradation produced by superimposing increasingly dense layers of elongated curves. Notice the "textured" look this creates.

Uneven horizontal strokes

Now fill in this shaded area with uneven horizontal lines. Move your wrist and arm in a rapid, even rhythm.

Horizontal parallel strokes, leaving a space

With the HB pencil, make horizontal, parallel strokes on both sides of an area contained by a curved line, as if each stroke passed behind the white area. Do not draw in the outline of the shape: Your drawing should look like the one on the left.

Shading a sphere

Here you can apply what you have learned from the exercise on uneven, horizontal lines. Reproduce the sphere on the top left by building up layers of strokes with the HB pencil, then by intensifying the tone with the 2B. Notice how, in this example, the direction of the strokes follows the lines of the sphere's surface (see the sketch, bottom right). This contributes greatly to the sense of form. However, it is perfectly possible to turn a circle into a sphere with just horizontal strokes (above, right) or vertical strokes, by means of gradations of tone.

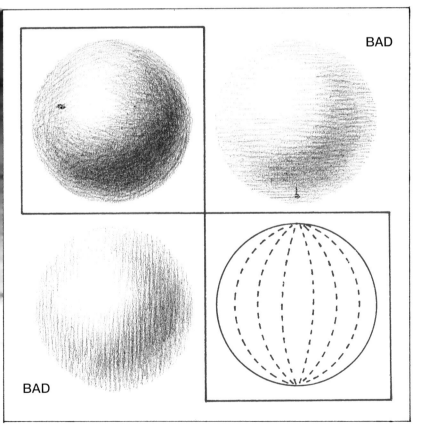

BAD

BAD

Applying the basic strokes

Now we are going to apply the previous exercises on basic pencil strokes to the drawing of a specific theme that we have set for you. However, before starting, remember that all our lessons and exercises need to be augmented by your own ideas in order for your learning process to be complete.

Look for and draw other simple subjects to which you can apply the same techniques as in our exercise.

Tonal evaluation

Let's look at our subject: Some cherries hanging from the branch of the tree. It is a subject that has no large areas of uniform tone but, rather, small spaces of considerable tonal diversity. Each leaf, each cherry, contains within itself a wide range of tones.

Look at the tonal analysis we produced in the adjacent illustration based on a scale of grays. The reference numbers indicate the scale value of specific areas of the drawing. This lesson in observation will help you avoid one of the most common mistakes made by beginners in drawing: Using too much dark tone. Making the dark areas too strong creates a false tonal value in which shadows become nothing but dark patches.

Our finished drawing (see page 27) has been carried out on paper with a fine grain using three pencils: HB, 2B, and 6B.

Cleanliness is vital

With this and every drawing, a lot of attention should be paid to keeping things clean; this can affect the appearance of the finished work. The drawing needs to be protected from your hand and anything else that might dirty the paper surface. It is also important to be neat during the drawing process: The white of the paper, as well as the gray tones, can be marred by being smudged by a clammy hand. Always work with a sheet of paper under your hand, changing it regularly so it won't begin to dirty your drawing instead of keeping it clean.

If you study our subject, you will notice that the highlights are pure white. At the bottom of the illustration you can see the numbered scale of grays representing the tonal values of different areas of the drawing.

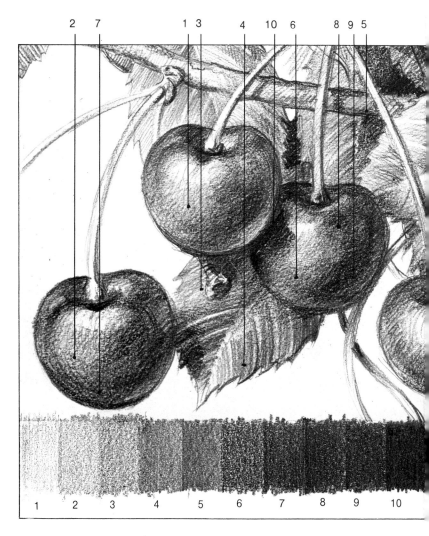

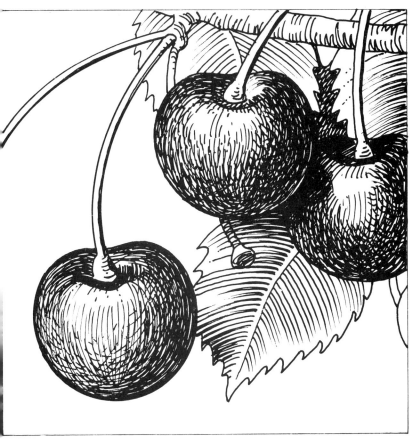

The direction of strokes

The direction of pencil strokes contributes greatly to the sense of depth and volume. It is especially important when representing forms contained within curved lines and also when we decide not to use the technique of blending strokes together—in other words, when we decide to work with nothing but the pencil (and an eraser, of course).

As a general rule, we should direct our strokes as if we were tracing the pencil lead over the surface of whatever we are drawing. Take a look at this pen and ink version of our subject and you will see how this principle has been applied. The lines follow the curves of the different surfaces. Now you should do the same with the pencil.

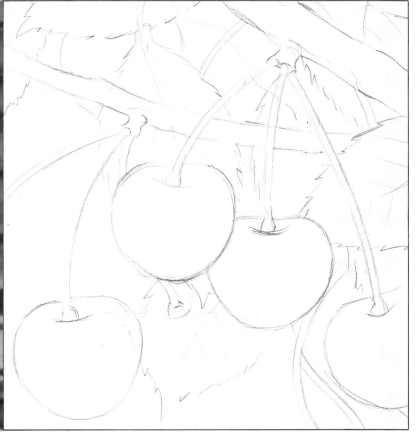

General outline

With an HB pencil, first situate and then outline the different forms that make up the subject, being as accurate as you can about the size and location of each. Make a few tentative lines, without pressing too hard, until you have decided where each element is to go. In this first exercise, we are leaving everything to your intuition. On later pages we will go into outline drawings and proportions. Just as we teach our hand to manage the pencil, we have to educate our eye to capture the shapes of objects and their proportions in relation to one another.

Look at our outline drawing and try to reproduce it on a piece of paper of approximately 8 × 10 in.

Setting the tone

Block in each part of the drawing using the appropriate base tone. Do this with an HB pencil without "using up" the blacker range of tones or allowing them to dominate at this early stage. Don't forget that the object of this exercise is to apply the basic strokes we studied in theory earlier. Notice, especially on the leaves, how the strokes are parallel and follow the curve of the surface.

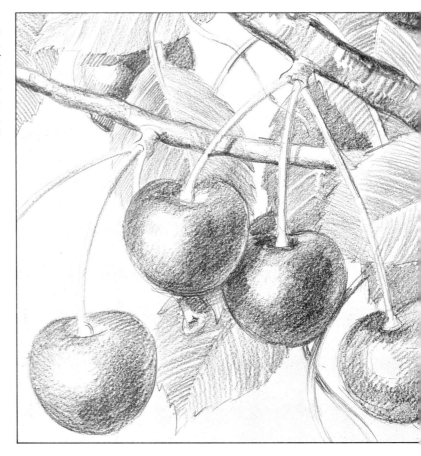

General build-up of tone

Using an HB and 2B pencil in combination, touch up any imperfections and correct the tonal values. Use the point of the pencil or its flat edge as required. Make use of the eraser too, harmonizing shading and gradations, frequently studying and comparing the different tonal intensities and adjusting them accordingly. Making your pencil (guided by your hand) obey orders from your brain (don't forget that drawing is an act of intelligence) is not something that happens immediately. With this in mind, if you are in doubt, stop for a moment and practice on a separate sheet, to find out if the position and pressure of your pencil and the direction of your strokes are the right ones for this drawing.

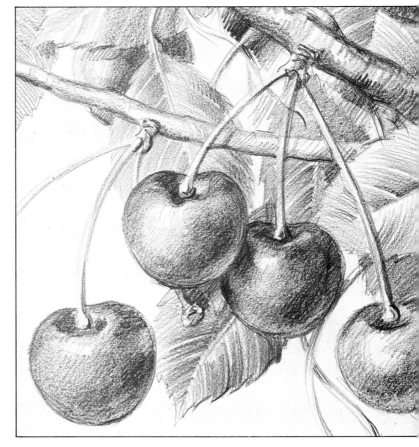

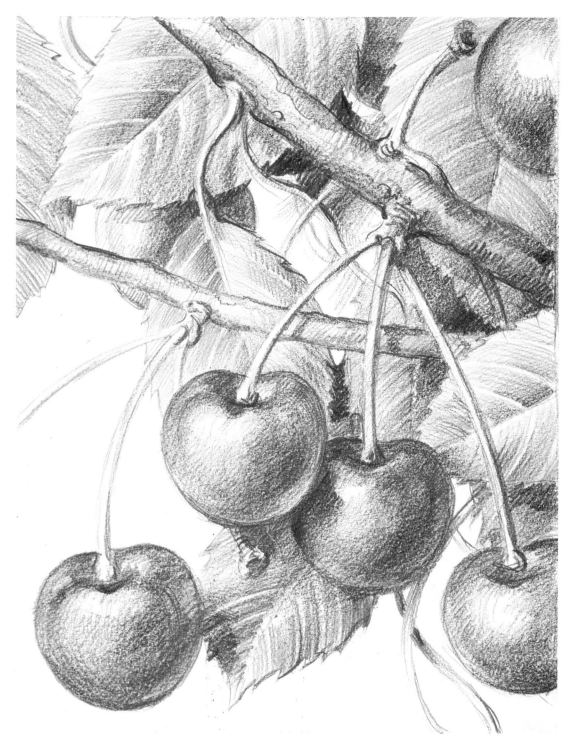

Tonal evaluation

Enhance the black areas with a 2B pencil, without overdoing the effect. Come to grips with the intense black of the shadows, extending and gradating them and bringing them into harmony with the other tonal values. This is a particularly enjoyable moment; it looks as though the drawing has been varnished, suddenly brought to life.

Heighten all the tones simultaneously, always seeing the drawing as a finished whole, at any stage in its production. Draw successive layers of strokes, progressively enhancing tones and contrasts as required, until you achieve exactly the right shade of gray.

The final touches have been added using a 6B pencil. These little details are always left until the very end: A highlight here, an outline there. Before applying a fixative to your drawing, leave it for two or three days, in case some last-minute alteration is needed. Once these have been made, you can go ahead and sign your first "work of art."

■ Training the eye

Every artist, and especially the beginner, often feels real terror when confronted by a blank sheet of paper.

The amateur takes one look and wonders, "What do I do next? Where do I start? I have the model in front of me, but what do I do first?" This amateur artist may have heard about the outline sketch and that the secret lies in looking at the objects as if they were blocks placed inside boxes, and developing the real shapes from this starting point. But the doubts continue: "How do I draw these boxes? Where? How big?"

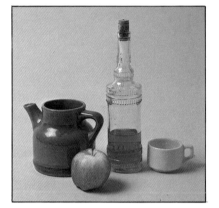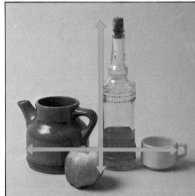

If you are in this situation, allow us to explain that the key to this problem lies in convincing yourself that a drawing, especially in its early stages, is never the result of chance or magical inspiration. A drawing is the product of your own intelligence. In order to draw you must apply reason. Simple reasoning, but absolutely logical, enables you to produce on the white paper the first strokes indicating the position and dimensions of the elements in your subject. Look closely at the example on the right and ask yourself:

"Where is the vertical axis of the picture?"

"How high up the bottle do the other elements of the composition reach?"

"How tall is the teapot in relation to the total height of the bottle?"

"How far from the vertical axis are the farthest width limits of the teapot and the cup?"

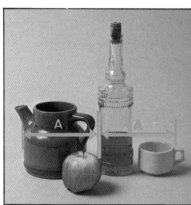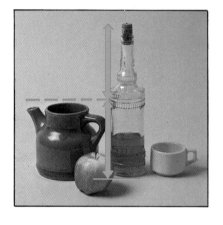

With the answers to these questions it is easy to set up "boxes" defining the height and width of the elements in the composition. The outline sketch is no more than the result of putting in some thought before beginning a drawing, a process that breaks down the barrier of anxiety caused by the blank page.

More than five hundred years ago, Leonardo da Vinci encouraged his pupils to exercise their "eye" to calculate the true dimensions of objects and then to compare them to establish simple arithmetical relationships between them.

We are going to look into this, so that in no time at all you will be able to cut a cake into twelve identical pieces, or set up a sketch of any object or composition of objects with four quick and accurate strokes. In short, we are going to take a lesson from the great Leonardo.

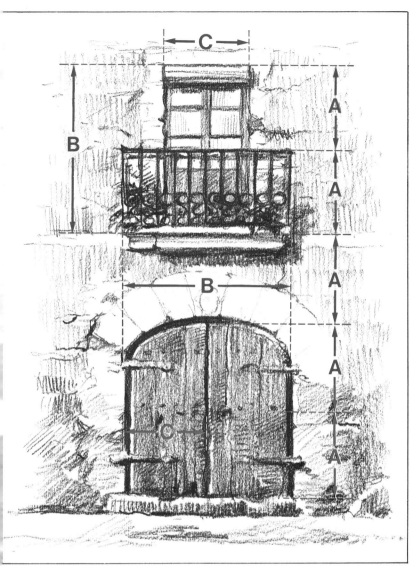

Making a mental calculation

Look at this illustration. It is an uncomplicated subject that will provide a good introduction to making mental calculations of distances.

Notice, for instance, that the distance between the base of the door and the lintel over the balcony may be divided into five equal parts, the lengths of which coincide with the height of the balcony rail. This observation allows us to establish all the basic height measurements of our subject as well as the widths, if we bear in mind that C (the width of the balcony door) is the same as the unit of height, A; as a consequence, B is equal to 2A.

With every subject it is possible to find measurements that relate to one another and can be compared in this way, whether they be whole parts, halves, or quarters. This task of analyzing a subject, checking measurements, and making an initial sketch, is essential before undertaking the definitive drawing.

Logically, there will be certain measurements that do not fit exactly within the pattern we begin to work out for a particular subject, but it will not be difficult to estimate these.

No doubt you will be asking yourself, "So, will I have to go through this measuring business every time I draw?" The answer is yes and no. Yes, because there is no outline sketch that does not require a certain amount of calculation of the basic measurements and proportions of the subject; and no, because, as your eye grows accustomed to gauging distances, you will become more confident using the pencil, reducing the need to "pause for thought." The time will come when your eye will be able to spot equal distances without needing to go through the whole mental process.

THE MENTAL CALCULATION OF DIMENSIONS CONSISTS OF:

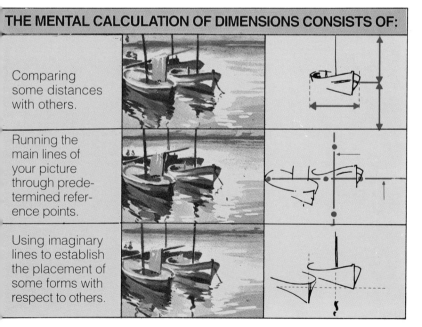

Comparing some distances with others.

Running the main lines of your picture through predetermined reference points.

Using imaginary lines to establish the placement of some forms with respect to others.

Above. In this illustration it can be seen that, by comparing distances, related proportions are discovered that allow key measurements to be established in a drawing.

The ideas on this page are only a small sample of the great variety of possible exercises on this subject. The type of paper and pencil you use here is not too important. The important thing is to work on a drawing board, situated a short distance from you. Work with your arm extended and with a firm grip on the pencil.

Draw on fairly large pieces of paper (a good-sized piece of packing paper, for instance) and remember that the harder the exercise, the sooner you will become adept at visually calculating distances. Repeat these exercises again and again—and any others you care to invent for yourself—until you can do them perfectly.

1

2

3

4

5

6

7

1. Draw a horizontal line about 8 in. (20 cm) and, using your eye, to find its center, divide it in two.

2. Draw a horizontal line and, beside it, another of the same length.

3. Draw a horizontal line about 6 in. (15 cm) and, beside it, another half its length.

4. Draw a horizontal line and, beside it, two parallel lines both half the length of the first.

5. Draw a square following the sequence shown in the illustration.

6. Draw another square, this time cut in half, following the sequence shown.

7. Draw a vertical line, then an "X" with the line passing through its center, and finally draw a square using the "X" as its diagonals, as shown in the illustration.

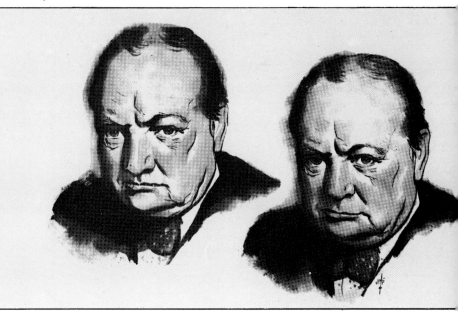

THE IMPORTANCE OF A MILLIMETER

These two drawings are both aimed at producing a likeness of Winston Churchill. Study the two results and see the effect that a distance of just one millimeter can have in any drawing. On the left, Churchill has been drawn with errors of distance between the eyes and between his nose and mouth. It's not Churchill anymore, is it? In the drawing on the right, the distances have been corrected.

Using the pencil for measuring proportions

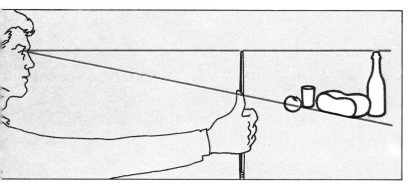

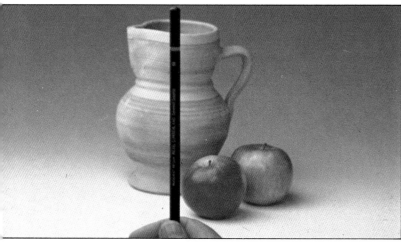

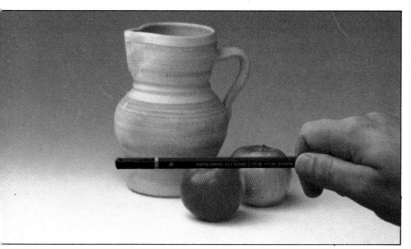

There will be few occasions when the real measurements of a model will be the same as when reproduced in a drawing. It is most likely that the objects will be drawn much smaller or, very occasionally, bigger than in reality. But the proportions of the model will indeed remain the same in most drawings.

When copying a drawing or a photograph, it is common to use a grid. This is a method well known to school children and even professionals use it from time to time. But what about establishing the proportions of a real life model? The most frequently used system revolves around a simple pencil, or paintbrush handle, or ruler. The precise tool is up to you. Look at the illustrations: Raise the pencil to the level of your eyes, extend your arm (return to this position every time you take a measurement) and situate the pencil in front of the part of the model you wish to measure. Move your thumb up and down until the visible part of the pencil coincides with the measurement of your model. Translate this measurement onto your paper and continue to use the pencil to measure the remaining proportions.

Compare distances frequently. Work meticulously, correcting proportions, relating them to one another, and indicating points of reference. Suddenly, without noticing it, you will find that your mind is working in a totally logical way.

Remember to calculate horizontal measurements as well as vertical ones, without ever altering the distance between your arm and the subject. To begin with, use this system for calculating the distances and proportions of simple objects, then go on to larger projects.

In these illustrations you can see how a pencil—or other, similar object—may be used to establish the dimensions of a chosen subject. Notice how the pencil is held and how to compare measurements of width and height. In this example, is the height greater? Or the width? Or are they the same?

It is very important to know how to set up the proportions of a picture. To illustrate this, on the right we have two sketches of the same subject, a jug and an apple, in which the correct proportions between the two elements have not been observed even though they could easily have been established.

The photograph shows our subject. On the right (above) it has been drawn on a smaller scale, but making the mistake of reproducing the apple on a similar scale, so that it seems proportionately much bigger than in reality. The other sketch shows the same subject with the apple drawn on too small a scale. These drawings show the effects of badly judged proportions.

In the same way, we see figure drawings in which the head seems out of proportion in relation to the body. This problem was resolved by artists in Ancient Greece who created formulas for the depiction of the human body, through which a basic unit of measurement was used to make simple calculations regarding proportions.

USE OF THE GRID

If a grid had been used (always assuming the subject was a photograph, of course), these errors in depicting the relative size of the apple would not have happened. But since, in this example, the artist was drawing from nature, he only had his eye to work with—which in this case let him down!

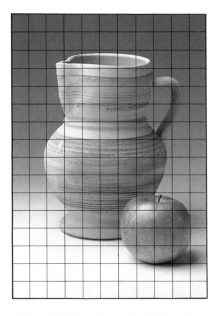

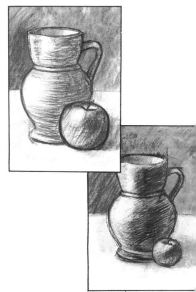

DÜRER'S INVENTION

Albrecht Dürer (1471—1528), German draftsman, painter, and engraver, invented various devices to help resolve the problem of dimensions and proportions of his chosen subjects. As we can see in the engraving, one of these devices consisted of a sheet of glass divided into squares and set in a frame, which the artist placed between himself and his model. He traced out a grid on a sheet of paper with the same number of squares—perhaps larger or smaller, but always the same number—and, maintaining a constant viewpoint, he translated the lines and curves of his model onto the paper, using the grid.

This system undoubtedly worked, however basic it might seem. After all, it is no more than a system of applying the "trick" of the grid to a real life model. But these applications of elementary geometrical principles (in this case, one of the criteria of proportionality) that so preoccupied Renaissance man, have never been able to replace the vision and mastery of form that the artist must have, both intuitively and as a result of training his own eye.

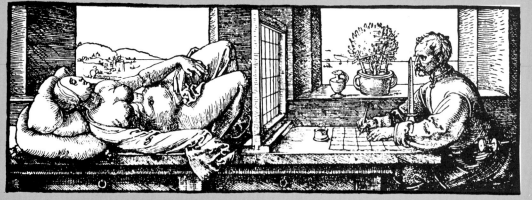

An engraving from the era. Alberto Durero is seen drawing with the help of a grid. Observe the reference situated in front of his eyes, the purpose being to always obtain the same point of view.

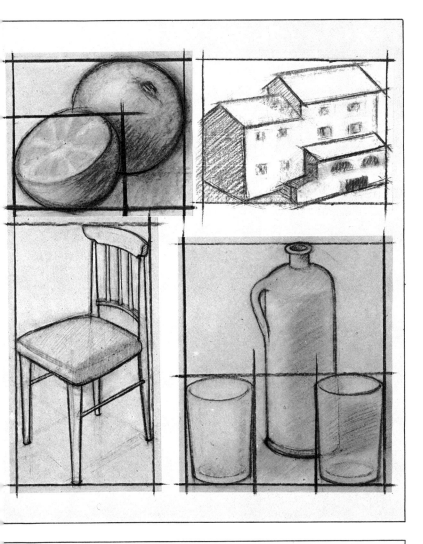

What is an outline drawing?

Cézanne used to say that "all the elements of nature can be seen in terms of cubes, spheres and cylinders."

It is true. Look around you: Everything you look at could be broken down into square, rectangular, or spherical forms—a table, an orange, a jug, a glass. Everything can be sketched out in an initial drawing that simplifies the graphic representation of its basic dimensions, its length, breadth, and height.

A rough outline, though, is not the same as constructing a frame into which the whole subject will fit. The artist must know how to identify the most important basic shapes to be included in this outline drawing. Look at the illustrations on the left and see how convenient it can be to calculate dimensions by means of an initial sketch consisting of cylinders, rectangles, or spheres.

So, to sum up, if you can draw a cylinder, a cube, or a sphere, you can draw anything, as long as you can calculate and compare distances and are able to draw the basic shapes that make up the proportions of your model.

Now imagine that you are carrying out the following exercise direct from life.

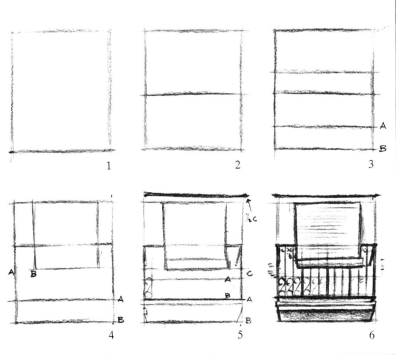

Take a pencil and paper and get ready to "think" along with us:

1. You are going to draw a balcony, complete with Venetian blind; you have already drawn the basic rectangle, observing the height-width ratio of the model.

2. You have noticed that the bottom of the blind comes to just below the half-way point of the rectangle and you have drawn this line.

3. Using the pencil system, you have calculated the thickness of the projection of the balcony (distance A-B) and have drawn a horizontal line passing through A.

4. The same distance A-B, taken from the left-hand vertical, also happens to bring you to the left limit of the blind. Draw in the two verticals and you now have your blind in the drawing.

5. You have noticed that the "unit" A-B can also help you establish the height of the balcony rail: the total height is A-B, plus C (which is half of A-B), plus another unit A-B.

6. To situate the bars of the railing, its entire width has been divided first in two, then in four, and finally into twelve equal parts. A few more details complete the perfect sketch.

See, think, and draw

Does this person on the right look familiar? Yes, it's Humphrey Bogart, one of the great legends of the silver screen. We have decided to draw his portrait, not for you to copy it (it might be a little soon for that), but to show you how important it is to train the eye to analyze a model, especially with a subject as involved as a portrait, in which the calculation of distances is critical. The likeness can often be lost by being a millimeter off (remember Churchill on page 30).

On this occasion, then, we are not asking you to draw—at least not immediately. Of course, if you want to copy our drawing, that's fine, but for now all we ask is that you follow the thought process of a professional artist who has drawn Bogart's portrait from the adjacent photograph.

First steps

Our artist has used a 2B pencil, an eraser, and a sheet of medium-textured cartridge paper about 8 3/4 × 12 in. (22 × 30 cm).

But before his pencil touches the paper, he spends a good while just analyzing the model. He notices that the vertical and horizontal axes of the photograph will be a useful reference for situating the parts of the face; they will help him to calculate distances. So he has drawn in these references—that is, the vertical and horizontal axes that divide the rectangle of the picture symmetrically.

"The ear, the chin, the left cheek, and the hat band define the edges of a sloping rectangle in which I am going to draw the face," says the artist.

In the same way, he points out that the hand and the telephone fit into a square in the bottom right-hand corner of the picture, also sloping at an angle (which he calculates by eye) to both axes. The artist has set up both these quadrilaterals within the drawing and, in doing so, has completed the first stage of the drawing. Naturally, this *definitive* stage will sometimes follow an earlier stage, rubbed out by the artist because it did not correspond to his idea of reality.

The definitive sketch

Now the different elements of the face are placed. The eyes, the nose, the ears, the mouth.

The artist continues: "The tip of the ear and the pupils of the eyes suggested to me a line sloping from the top left quarter of the picture to the intersection of the horizontal axis on the right edge of the picture. This line is parallel to the upper (hat band) side and the lower (chin) side of the rectangle containing the face. Also, the bridge of the nose forms a vertical line that cuts through exactly a third on the horizontal axis."

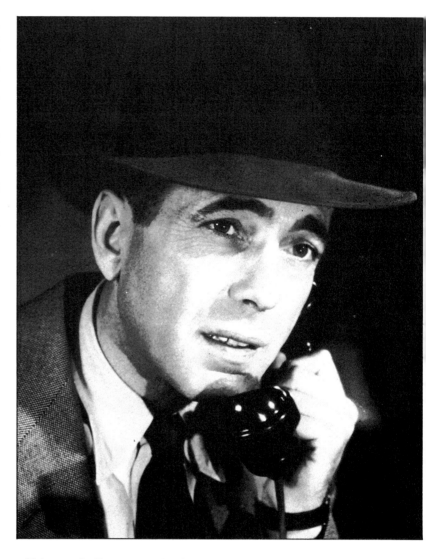

Using a similar approach, the artist has broken the face down into small parts to place the mouth, eyes, eyebrows, fingers, and so on.

Remember that any model, however complex it seems, may be analyzed as if it were a puzzle. All you need is to find and separate the series of pieces that, when joined together, make up the whole.

It is a matter of simplifying shapes, establishing proportions, and situating them in the picture; of identifying very simple forms in more and more detail, until eventually we reach the stage of defining more complicated ones—all of which, of course, is much easier to talk about than to do. But let's get back to Bogart and his portrait.

The estimate of distances begins when we try to see the most convenient methods for dividing the image. This can be done in limited segments by reference lines that simplify the measurements and permit us to place all the elements of the model on the exact spot on the paper.

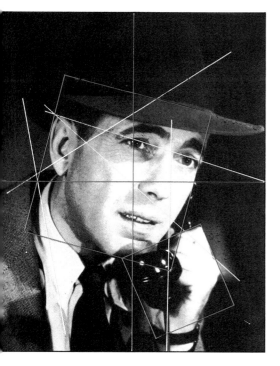

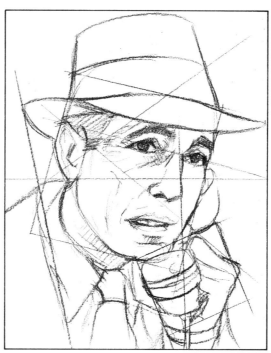

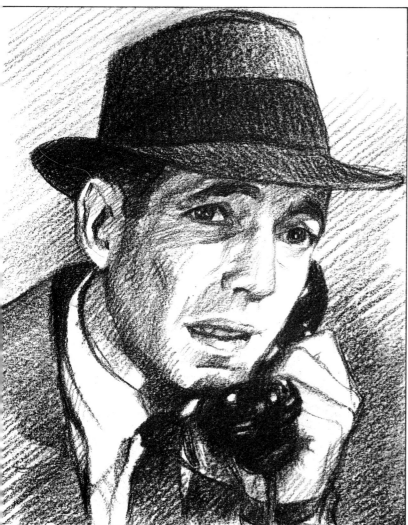

Final stage

The artist has sketched in the position of the fingers and the arrangement of the hand. He has firmly defined the lines of the clothing and has carefully darkened the shaded areas.

This is the moment when, just as the drawing is about to be built up strongly, it is worth going away from it altogether for a few minutes.

When you return to your drawing after a short while you will discover and be able to correct any errors with confidence.

We will take advantage of this little pause to remind you that you need not limit yourself to this portrait of Bogart. Look for another portrait that you would enjoy doing and apply the same analytical process to your own drawing: Situate your axes, draw in boxes for the different parts of your sketch, positioning lines for the eyes, nose, mouth, chin, and so on.

Light and shade

Edouard Manet said in 1870: "The main personality in any painting is light." Manet, like all the Impressionists, was very aware that color is light. Light and shade is what we are going to study now and, by way of an introduction, we are going to take a look at three theoretical aspects of light that might be of interest to the artist.

The direction of light

Basically, a model can be illuminated by:

Front light. Lighting from directly in front of the subject produces hardly any shadow.

Angled-front light. This is light from one side hitting the subject at a 45-degree angle. It creates an even balance between illuminated and shaded areas.

Side light. This is light from one side that leaves the opposite side in shadow. It makes the subject more dramatic and is used to create special emphasis or contrasts.

Back light. In this case the main light comes from behind the subject. As a result the foremost planes of the subject are in total shadow. Back light or semi-back light creates interesting possibilities when painting landscapes.

Light from above. This is usually sunlight coming from an opening in the roof of the studio. It is ideal for life drawing or painting.

Light from below. This is only used in very special circumstances to achieve a dramatic effect.

The quantity of light

This will affect the tonal contrasts the subject offers and that, as a consequence, the artist can recreate in his drawing.

A subject illuminated by an intense light will present marked shadows. Conversely, a weak light will diminish contrasts and create an overall evenness of tone.

The quality of light

By quality of light, we mean whether or not it is natural and the conditions under which it falls on the subject. For example:

Natural light. Light from the sun.

Artificial light. Light produced by electric lamps or other methods.

Direct light. Light hitting the subject directly either from a natural or an artificial source.

Diffused light. Natural light on a cloudy day, or light coming through a window or doorway, hitting the subject indirectly after bouncing off a wall, ceiling, floor, and so forth.

The vocabulary of light

When artists talk about light, in the context of drawing and painting, they use certain words and expressions, the meanings of which do not always coincide with their scientific definitions. Here are a few:

Light areas. Directly illuminated areas of the subject not affected by reflections.

Highlight. The effect created by contrasting a white area with a darker area beside it.

Shade. The shaded areas on the object itself.

Shadow. The area of shade projected by the shape of the subject onto adjacent surfaces (the floor, wall, other objects, and so forth).

Half light. Area of medium tone between an illuminated and a shaded area.

To sum up: When a subject is illuminated, areas of light, half light and shade are produced. At the same time, the illuminated body projects its own shadow onto nearby surfaces and objects. The shade and shadows are themselves affected by the reflected light from adjacent surfaces.

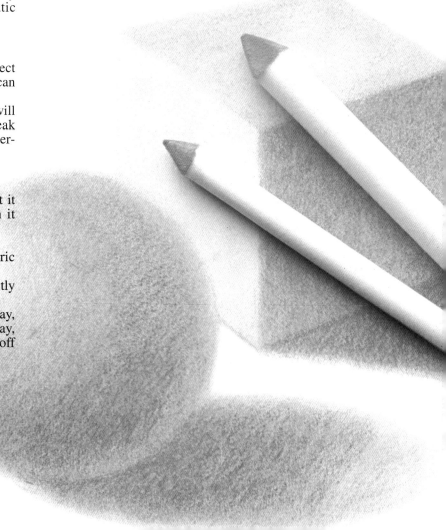

Shading with the finger or torchon

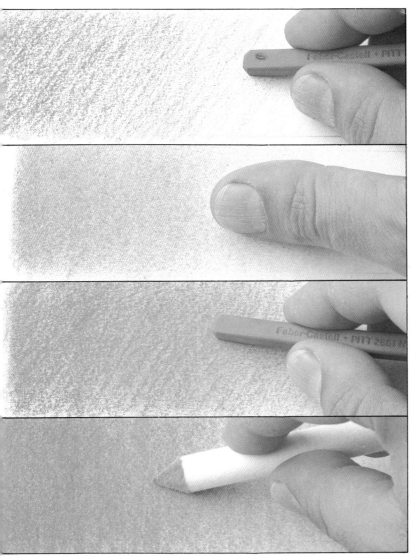

The effects of light and shade in a drawing depend on the correct application of various uniform and gradated areas of tone. In view of this, we believe that the following exercise, which consists of creating different types of shading with a sanguine crayon, will be very useful in teaching you how to convey shadow, to represent in a drawing the effects of light and shade.

First of all, carefully cover a predetermined area with sanguine crayon, applying the strokes very close together. Blend this area with the fingertip, using circular or zig-zag movements, until a uniform tone has been achieved over the whole area.

Now apply another layer of sanguine crayon and blend it in again, this time gradating the color at the same time by spreading the pigment towards the right to create a pale area that will enhance the dark-to-light effect of the gradation. As a complement to this exercise, draw another layer of sanguine crayon, blending it with the finger and creating a uniform tone with the aid of a torchon. Also, discover for yourself how you can draw with an eraser; practice bringing out different whites by using it on plain, shaded backgrounds.

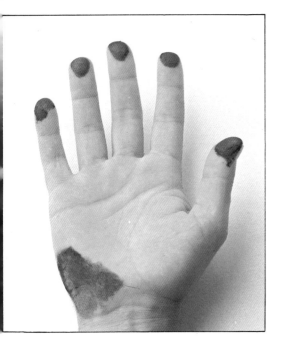

Left. *Here you can see how effective your own hand can be in creating shading and gradations. Don't forget the lower palm of the hand, which is useful for blocking in large areas of uniform tone.*

Right. *Paradoxically, the eraser is also a drawing tool, useful for opening up highlights, defining angles, and sharpening edges. Here we have used a normal eraser on the gradation.*

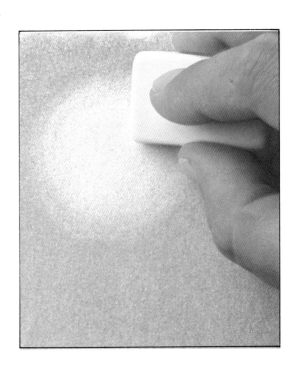

Light and shade. Elementary study

Right. *Natural, diffused light creates soft shadow forms (left-hand photo).* *Artificial light from a bulb heightens contrasts (right-hand photo).*

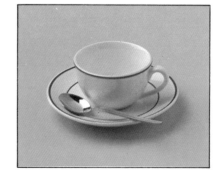

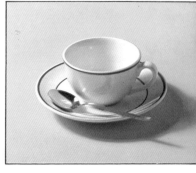

The direction and quality of light

We are going to give you an exercise to demonstrate the effects of light and shade in which, as always, the direction and quality of light are highly influential. This is why, before starting the exercise, we would like you to see for yourself how the appearance of a subject is greatly affected by varying the direction and quality of light. We have already said that light can come from above, below, beside, or behind a subject—indeed, from any direction imaginable!

To illustrate our point, look at these four extremes and the effects they produce on a plaster cast reproduction of the famous Venus de Milo.

1. Light from above. This produces distinct shaded areas (provided the light is intense enough, of course) that emphasize the volume of the model, giving it an unusual appearance.

2. Light from below. The shadows extend upwards. The resulting effect is almost unearthly.

3. Back light. The light comes from behind, leaving the foremost areas of the model in shade, while a characteristic halo of light can be seen around the outline of the figure.

4. Side light. The light is coming entirely from one side, so that at least half the model is in the shade. This emphasizes volume and depth.

In each case, the perfect sense of depth is achieved in a drawing when a balance of tone accurately conveys the contrasts between areas of light, shade, and half light, and when these areas are successfully blended into one another.

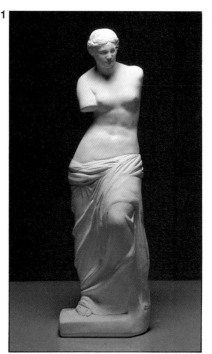

1

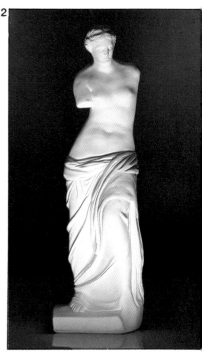

2

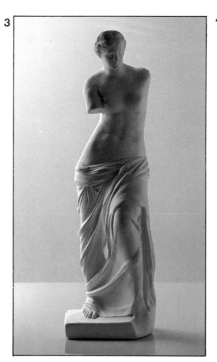

3

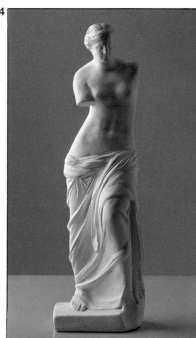

4

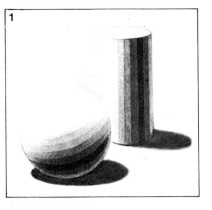

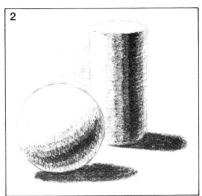

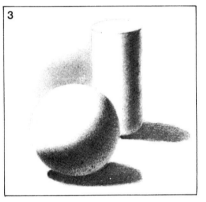

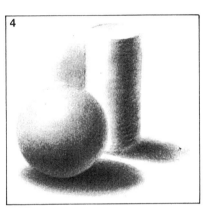

Effects of light and shade on a white sphere and cylinder

It is easy to build a cylinder from white card and, as for the sphere, you can buy a little ball of cork or any other material and cover it with matte white paint.

Place both objects on a white background and light them artificially from the side. Then, using an HB pencil, an eraser, and a smooth paper, do the following exercises:

1. Draw lines dividing the cylinder and the sphere into equal parts and, beginning with the line where you think the half-tone starts, build up bands of tone, ranging from the palest through to the darkest gray.

Notice that on the shaded side, the figures show a thin line of reflected light. Don't forget about it!

2. Repeat the exercise, working in bands, but this time without drawing in dividing lines beforehand.

3. Repeat the previous exercise and blend the grays together, so that the transition from light, to half light and shade is smooth and continuous.

4. This time spread the gradation, extending the areas of half tone, to create an effect more like that produced by diffused light, as opposed to example 3, which is created by a more intense light source. The eraser is useful for cleaning up highlighted areas and for defining areas of shade. Notice the clearly visible area of half light around the edges of the projected shadows.

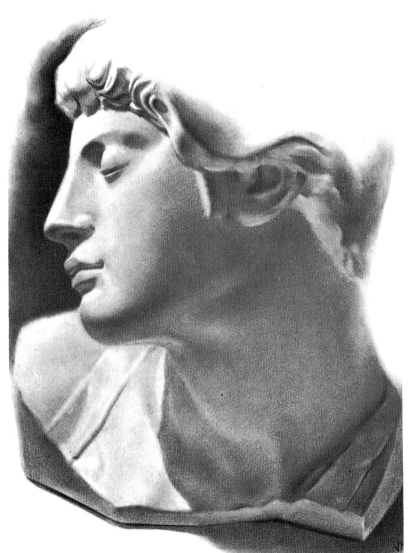

Left. A sample of how an incredible sense of light and depth can be created through the technique of blending light and shaded areas. This magnificent study was produced with a 2B graphite pencil on cartridge paper.

Study of drapery in sanguine crayon

Great artists throughout history have paid maximum attention to the study of drapery in their pictures. Think of the famous tablecloths on which Cézanne set his wonderful still life paintings. Today, in fine art schools, the study of drapery is still considered an excellent method of learning about the effects of light and shade.

On the right, we can see a drawing of cushions produced by Dürer in his youth, in which he tried to capture with "dry" strokes the effects of light and shade caused by the folds of cloth. You should follow the example of the great masters: Take a piece of white or plain cloth and arrange it on a table or hanging from a wall, so that it falls in folds or pleats. Draw these folds, analyzing their tonal values. You will discover the infinite range of shades offered by this sort of subject.

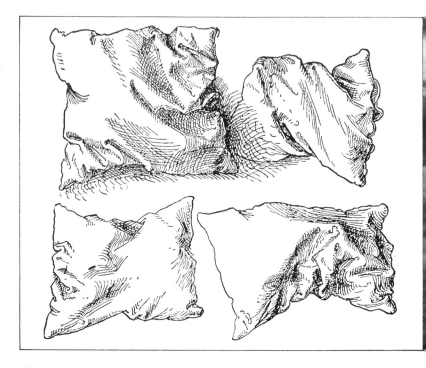

Right. Detail from "David, conqueror of Goliath" by Caravaggio (1576–1610), oil on canvas.

Below. "Virgin with Child, a saint and an angel," by Andrea del Sarto (1486–1531), oil on panel. In both details we can see the attention the great masters gave to drapery.

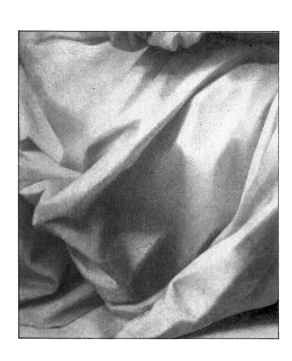

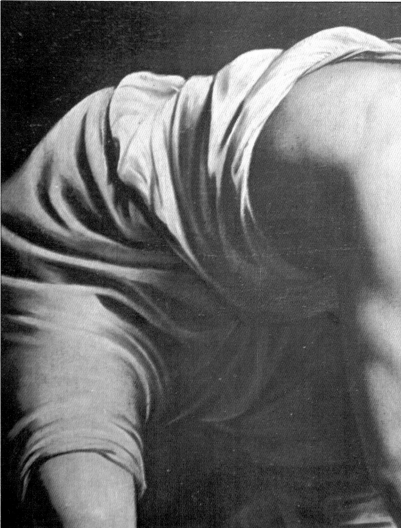

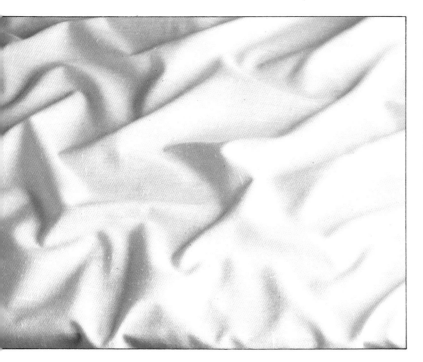

Arrangement of the subject

We will now take a large piece of white cloth and draw it "from nature," a compulsory exercise in fine art schools. On this page we show you three possible arrangements of the subject, culminating in the definitive version, below right. As always, we stress that you do not have to use our suggestion; study different versions, look for forms that appeal to you and, using the lessons of the following pages, carry out other exercises based on your own arrangements.

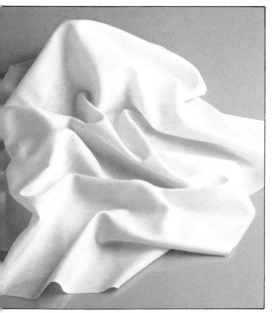

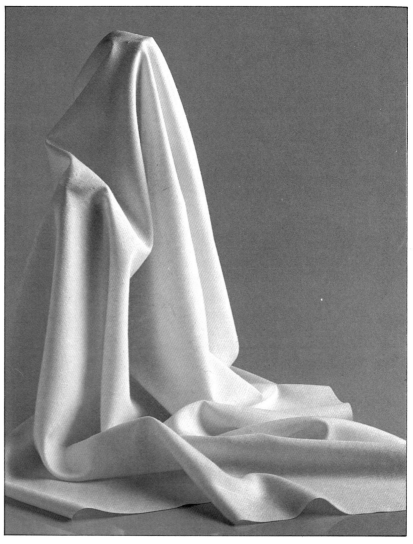

Above. In this first option the light is too direct and the cloth is arranged in a way that does not produce interesting shadows.

Below, left. This second option is better, but the light is still inadequate.

Right. This one will do! The contrasts are excellent, the folds create some marked shadows and the composition is perfect.

Now we are going to draw the drapery we arranged on the previous page, using sanguine crayon on a sheet of medium-textured paper, or Ingres paper if you prefer. We recommend that you use a fairly large sheet for these exercises—about 19 × 27 in. (50 × 70 cm, for example), which will allow you room to maneuver with crayon, fingers, and eraser. Shall we begin?

Initial sketch and base tone

With soft strokes the lines of each fold are established and on top of the outline drawing, a base tone is blocked in providing the first areas of shading. Notice how the slanting strokes help to define the different planes and the structure of the folds.

First blending

Blend the image with the fingers, even darkening the whites, although only lightly. Then build up the forms with sanguine crayon, using the eraser to correct any little slips. Compare the drawing of this stage with the finished drawing on the next page: Here, the whites are dirty with the tone produced by rubbing fingers; in the definitive version, there are two whites, the same dirty white of this stage and a brilliant, total white picking out the contrasts of the most illuminated folds. This second white has been achieved with the help of the eraser.

Remember the method of blending with the fingers in a circular motion to mold the forms, but without eliminating all the strokes from the previous stage, which clearly define the different parts of the folds. To sum up, this phase is about evaluating, comparing, intensifying, and harmonizing tone, simultaneously throughout the picture.

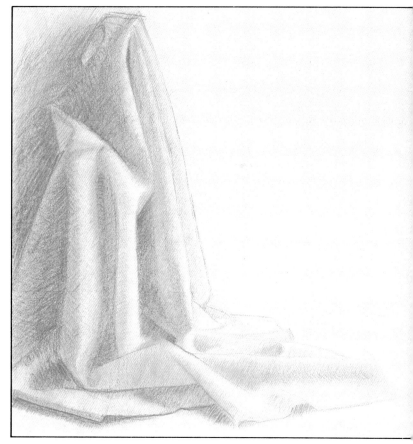

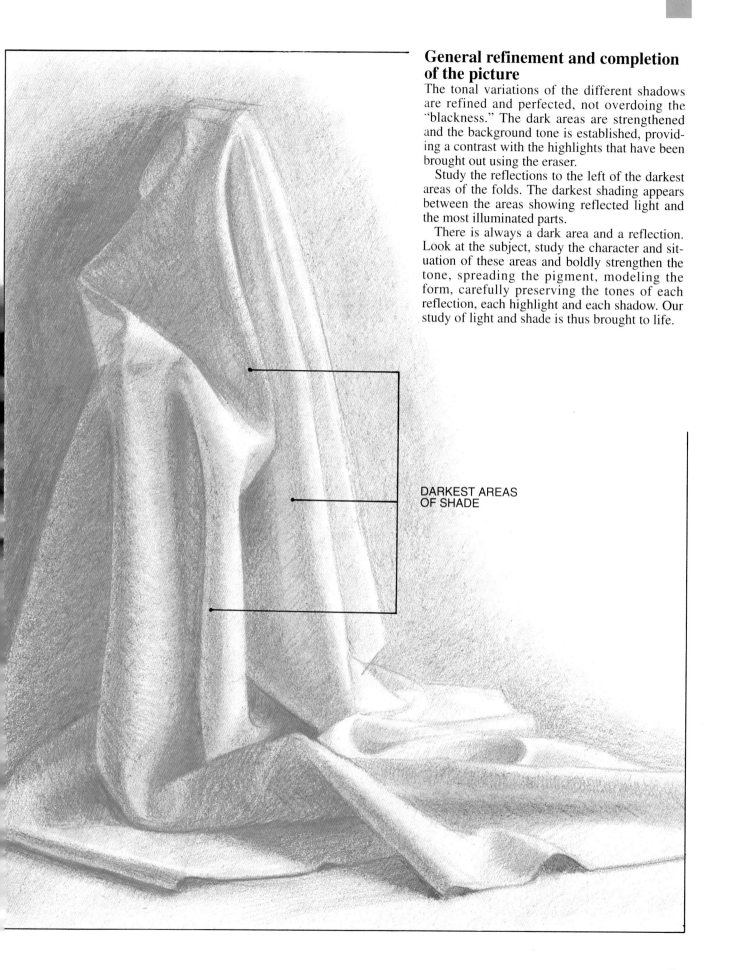

General refinement and completion of the picture

The tonal variations of the different shadows are refined and perfected, not overdoing the "blackness." The dark areas are strengthened and the background tone is established, providing a contrast with the highlights that have been brought out using the eraser.

Study the reflections to the left of the darkest areas of the folds. The darkest shading appears between the areas showing reflected light and the most illuminated parts.

There is always a dark area and a reflection. Look at the subject, study the character and situation of these areas and boldly strengthen the tone, spreading the pigment, modeling the form, carefully preserving the tones of each reflection, each highlight and each shadow. Our study of light and shade is thus brought to life.

DARKEST AREAS
OF SHADE

Perspective

One morning in 1909, Pablo Picasso was painting a portrait of Ambroise Vollard, a famous art dealer and friend of most of the famous painters of the era. Picasso was looking through half-closed eyes, detecting angles, quadrilaterals, and cubes in the face of Monsieur Vollard. This was the beginning of the cubist period of the genius from Málaga.

"Let's rest for a while," said the artist, noticing that the subject was looking tired.

Vollard stood up, walked to the window and, while observing the hubbub of the city, remarked, "I was remembering poor Cézanne." (Cézanne had died three years earlier.) "He also painted my portrait, as you are doing now. Cézanne, Monet, Renoir, Sisley...!" Vollard's eyes grew misty with nostalgia. "The most famous group of painters France has ever seen!" he pronounced.

"Yes, but Cézanne ended up turning his back on all of them," Picasso replied, preparing a new mixture of color.

Vollard seemed not to hear this caustic remark. Resuming his position in front of the canvas, he said "He was a very special character. I can almost hear his voice with his rough, Provençal accent, shouting: *Boys, the trick is to reduce everything to cubes, cylinders, and spheres!*"

He smiled at his own clever impersonation, and Picasso started to show signs of impatience.

"Shall we continue, Monsieur Vollard?"

The subject contained the avalanche of reminiscences hovering over his thoughts and adopted the pose Picasso suggested. For the next few minutes, all that could be heard in the studio was the scratching of the paintbrush on the canvas. Suddenly, Picasso's voice broke the silence.

"Cézanne was right!" he said emphatically.

And he continued trying to find new angles, quadrilaterals, and cubes in the face of his friend, Ambroise Vollard.

Cézanne's words are the perfect introduction to our discussion of perspective, which we are going to explore.

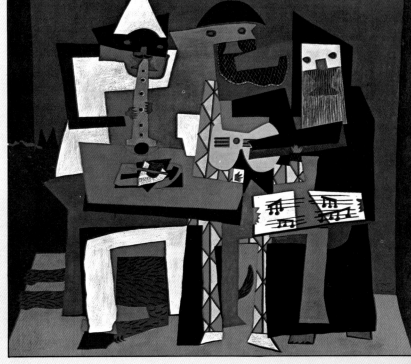

"The Three Musicians", Pablo Picasso, 1921, oil on canvas. Museum of Modern Art, New York. A significant example of Picasso's cubist period, with all the logical geometric qualities.

Parallel perspective of a cube

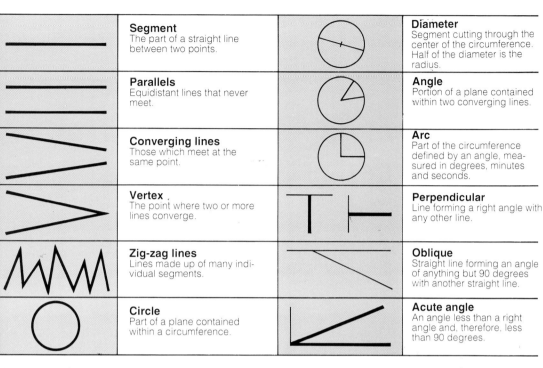

Segment The part of a straight line between two points.		**Diameter** Segment cutting through the center of the circumference. Half of the diameter is the radius.	
Parallels Equidistant lines that never meet.		**Angle** Portion of a plane contained within two converging lines.	
Converging lines Those which meet at the same point.		**Arc** Part of the circumference defined by an angle, measured in degrees, minutes and seconds.	
Vertex The point where two or more lines converge.		**Perpendicular** Line forming a right angle with any other line.	
Zig-zag lines Lines made up of many individual segments.		**Oblique** Straight line forming an angle of anything but 90 degrees with another straight line.	
Circle Part of a plane contained within a circumference.		**Acute angle** An angle less than a right angle and, therefore, less than 90 degrees.	

Yes, unfortunately, it is necessary to go into the cold and exact science of geometry if we wish to draw perspective correctly. We must begin by clarifying a few definitions. These are concepts that appear constantly in any perspective drawing.

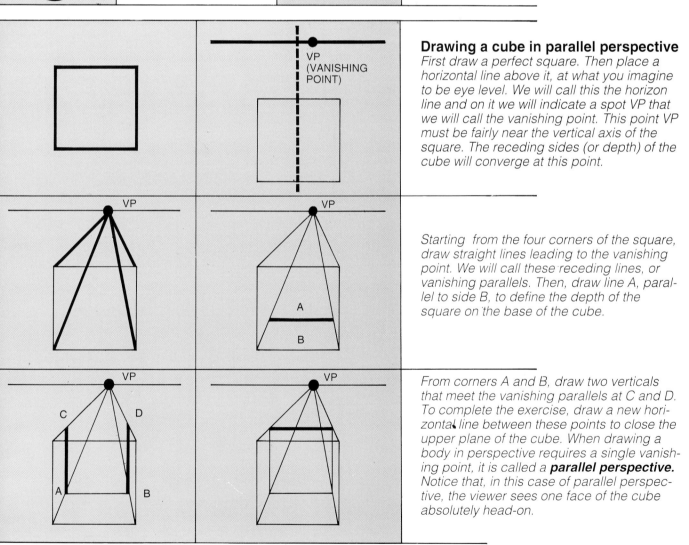

Drawing a cube in parallel perspective
First draw a perfect square. Then place a horizontal line above it, at what you imagine to be eye level. We will call this the horizon line and on it we will indicate a spot VP that we will call the vanishing point. This point VP must be fairly near the vertical axis of the square. The receding sides (or depth) of the cube will converge at this point.

Starting from the four corners of the square, draw straight lines leading to the vanishing point. We will call these receding lines, or vanishing parallels. Then, draw line A, parallel to side B, to define the depth of the square on the base of the cube.

*From corners A and B, draw two verticals that meet the vanishing parallels at C and D. To complete the exercise, draw a new horizontal line between these points to close the upper plane of the cube. When drawing a body in perspective requires a single vanishing point, it is called a **parallel perspective.** Notice that, in this case of parallel perspective, the viewer sees one face of the cube absolutely head-on.*

Oblique and aerial perspective of a cube

We are now going to draw a cube in perspective when none of its sides completely face the artist. The consequence of this is that we have not just one set of vanishing parallels, but two, with corresponding vanishing points on the horizon.

Cube in oblique perspective

1. Draw the side of the cube closest to you.
2. Draw, in perspective, the foremost face of the cube, bearing in mind that the edges of each plane, seen in perspective, must run to a vanishing point on the horizon.
3. Extend sides A and B to their vanishing points and draw in the horizon line.
4. Now draw the face of the cube that forms an angle with the first.
5. Mark in the second vanishing point.
6. Draw the lines A and B that define the upper face of the cube.
7. To create the effect of a glass cube, draw in sides A, B, and C.

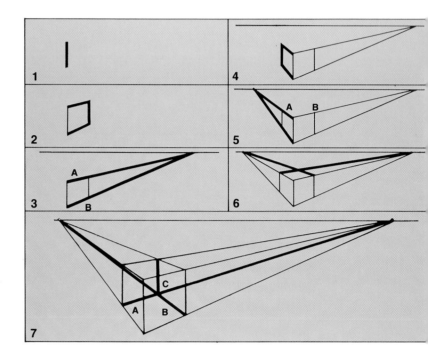

Aerial or three-point perspective of a cube

1. Draw a square in oblique perspective, with a fairly high horizon line.
2. Draw a vertical that passes through the center of the first square.
3. Draw the side of the cube nearest to you. Bear in mind that when this side is extended downwards, it will run to a vanishing point on the vertical line at a level that depends on the height from which the cube is viewed. The higher the view-point, the nearer the base of the cube this third vanishing point will be.
4. Draw the most visible face of the cube. Side A will run to the same vanishing point on the vertical that we just mentioned.
5. Make sure that the slope of these vertical parallels brings them to meet at the third vanishing point on the line perpendicular to the horizon.
6. Draw in the "invisible" lines of the cube as if it were made of glass if you find this helpful, and make any necessary adjustments.

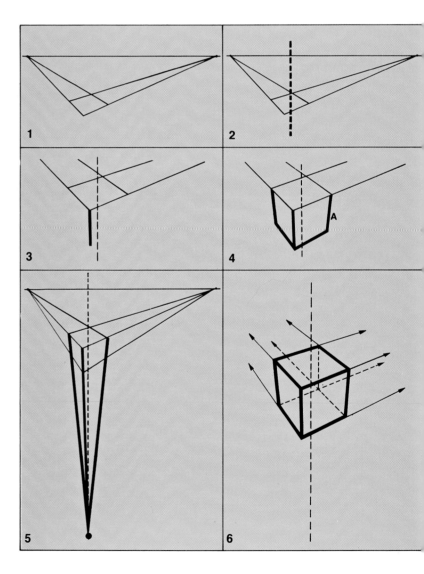

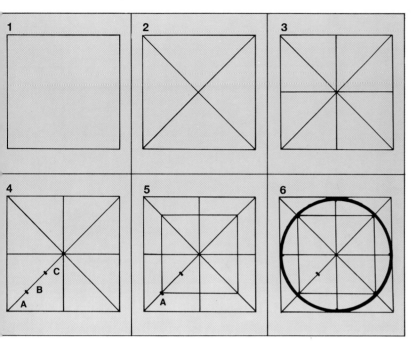

Drawing a circle in parallel and oblique perspective.

To draw a free-hand circle, follow this method:

1. Draw a square in which to construct your circle.

2. Trace its diagonals.

3. Draw in the vertical and horizontal axes of the square.

4. Divide one half of a diagonal into three equal parts at A, B, and C.

5. Starting at point A, draw another square inside the first. By doing this, you have now created eight reference points on which to build your circle.

6. Draw the circle free hand, making it pass through the eight points you have established.

So, to draw a circle in perspective, you have to start by drawing a square in perspective.

Imagine that, after drawing a geometrically perfect circle, you place it on the floor and walk a few paces away from it. You will, naturally, see it in perspective: In parallel perspective, if it is situated so that you are looking head-on at one of the sides of the square in which it was framed (as in the picture on the left), and in oblique perspective if you are not.

Everything depends on drawing a square in perspective and then following this process:

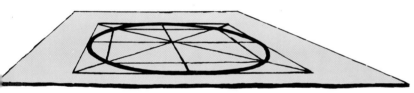

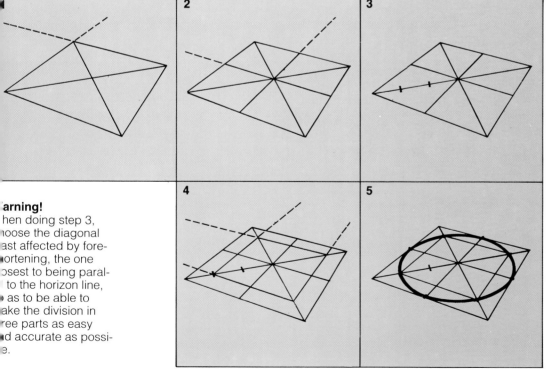

1. Draw the diagonals of the square.

2. Draw the cross through the center with the lines running to their respective vanishing points.

3. Divide one half of a diagonal in three parts.

4. Draw a new square inside the first, starting from the first "third" from the edge.

5. Draw in the circumference by hand, using the eight reference points as a guide.

Warning!
When doing step 3, choose the diagonal least affected by foreshortening, the one closest to being parallel to the horizon line, so as to be able to make the division in three parts as easy and accurate as possible.

Perspective of geometric forms

Parallel perspective of a cylinder

Being able to produce, free-hand, the basic geometric shapes in perspective (cube, prisms, cylinder, pyramid, cone, and sphere) is essential if we wish to construct complex compositions. Still life drawings, landscapes, seascapes, interiors, and even figure drawing, can be reduced to these forms at the stage of composition and making an outline sketch.

Look at the four stages of producing a cylinder in parallel perspective shown on the right.

To draw a cylinder in oblique perspective, you will have to draw the prism containing it with two vanishing points, as in the example of the cone on the next page.

Whenever you want to draw a figure with a circular base, you will first have to construct in parallel or oblique perspective, depending on your requirements, the square-based prism in which you think it will fit, and then trace in perspective the circles of the upper and lower planes.

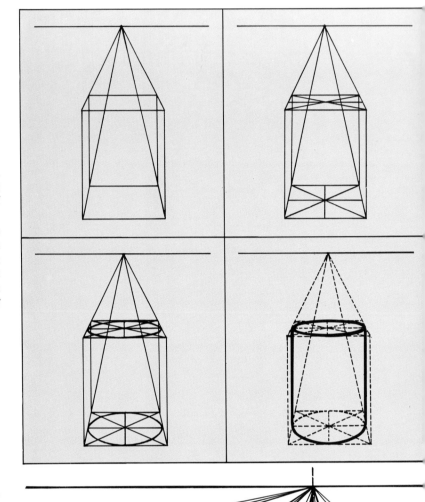

Common mistakes in drawing cylindrical forms in perspective

We mentioned earlier, when we were drawing the cube in parallel perspective, the importance of keeping the vanishing point close to the visual center of the cube.

When drawing cylinders from the side, we discover the importance of following this same recommendation. Parallel perspective implies seeing the object from in front (B), not from the side, as in example A. The distortion of this first cylinder happens because, in reality, the figure would be well outside the normal field of vision, so that to see it we would have to change our position or draw it in oblique perspective.

To avoid imperfections when drawing in perspective, always imagine that the figures you are drawing—in this case a cylinder—are transparent and that the invisible lines passing through them are visible. It is a trick many professionals use to set up or adjust the perspective of their compositions.

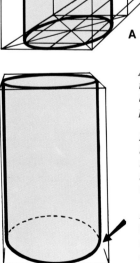

Above. The cylinder on the left is distorted because its vanishing point is too far away.

Right. WRONG: The base of the cylinder is not true, because the perspective has been incorrectly drawn.

Left. RIGHT: The trick of the "glass" cube has contributed to a perfect construction.

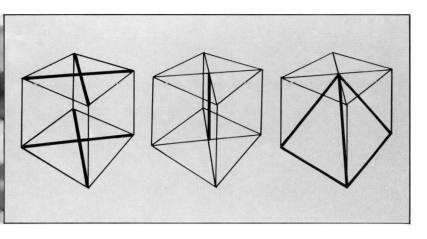

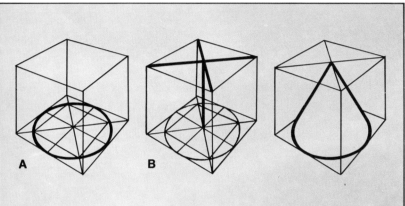

Drawing a pyramid and a cone in oblique perspective

Now that you know how to draw a cube in perspective, this exercise will not be difficult. It involves drawing in oblique perspective the cube or prism that contains the figure you wish to draw: In this case a pyramid with a square base and a cone. The diagonals of the upper and lower squares are drawn and their intersection joined by a vertical line that ensures the cube is correctly constructed. All that remains now is for the corners of the lower square to be linked to the central point of the upper square, and you have your pyramid.

Do this exercise several times, varying the position of the cube. As for the cone, it is produced by drawing a cube with a circle on its base; the center of the upper square is again found by drawing diagonals; this central point is then linked to the outline of the circle forming the face of the cone.

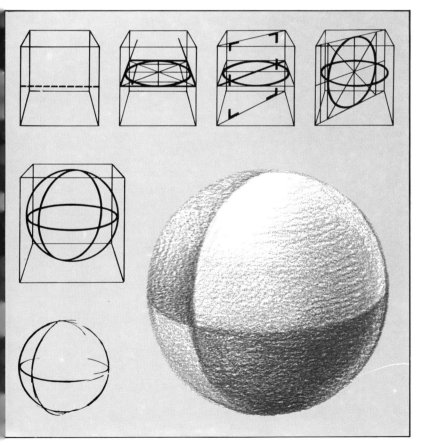

Perspective of a sphere

In practice, when an artist needs a sphere to form part of a composition (an orange for a still-life, an architectural adornment, and so forth), he tends just to draw a circumference with the appropriate diameter, and that's it! In creative drawing we work on the basis that a sphere always looks "round" whichever way you look at it. However, it is worth knowing that the sphere does have its own perspective and that, in theory as well as in practice, its poles, its meridians, and its parallels are situated and seen in a different way depending on your viewpoint.

So it is worth looking at the perspective of the sphere formed by combining the perspectives of different circles we could describe as its equator and its meridians, as shown in the drawings on the left.

Cubes, prisms... buildings!

Below. *Typical example of oblique perspective, with the vanishing points outside the picture. Notice that all the lines on the subject, which are parallel in reality, run to the same point on the horizon. In this building, seen in oblique perspective, we have two sets of vanishing parallels that converge, respectively, at one point situated off to the right and another off to the left. Notice also how the perspective of these simple structures can be reduced to the perspective of cubes and prisms.*

Right. *This diagram is a good example of parallel perspective: It shows a single vanishing point that is, at the same time, the center of vision. Three important things are clear here: The sides (or lines) of the buildings in reality are vertical (e.g. line V in the drawing) and when seen in perspective continue to be vertical; they never meet.*

Horizontal lines, in reality horizontal and parallel to the horizon line (e.g. line H), remain horizontal.

Finally: Lines which are in reality horizontal and perpendicular to the picture plane (e.g. line P) are, in a perspective drawing, vanishing parallel lines that converge on the center of vision (CV).

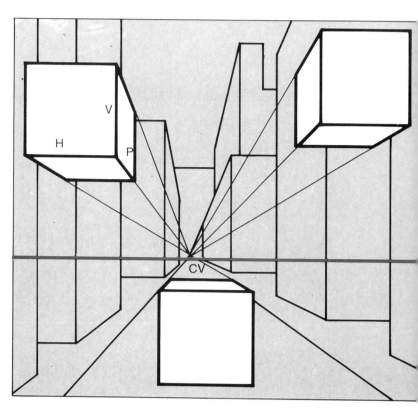

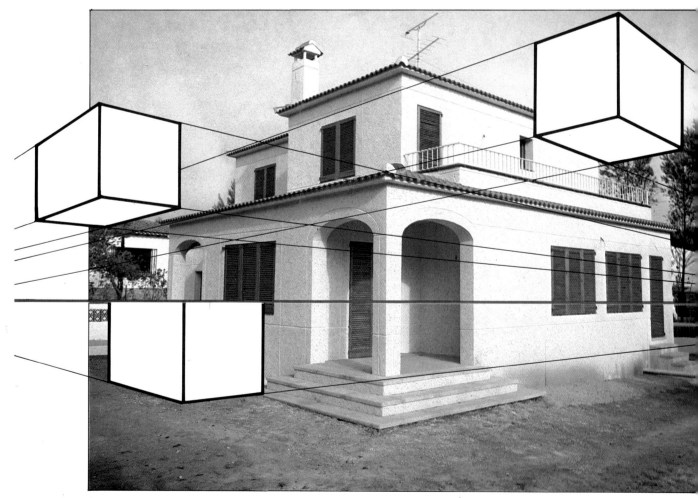

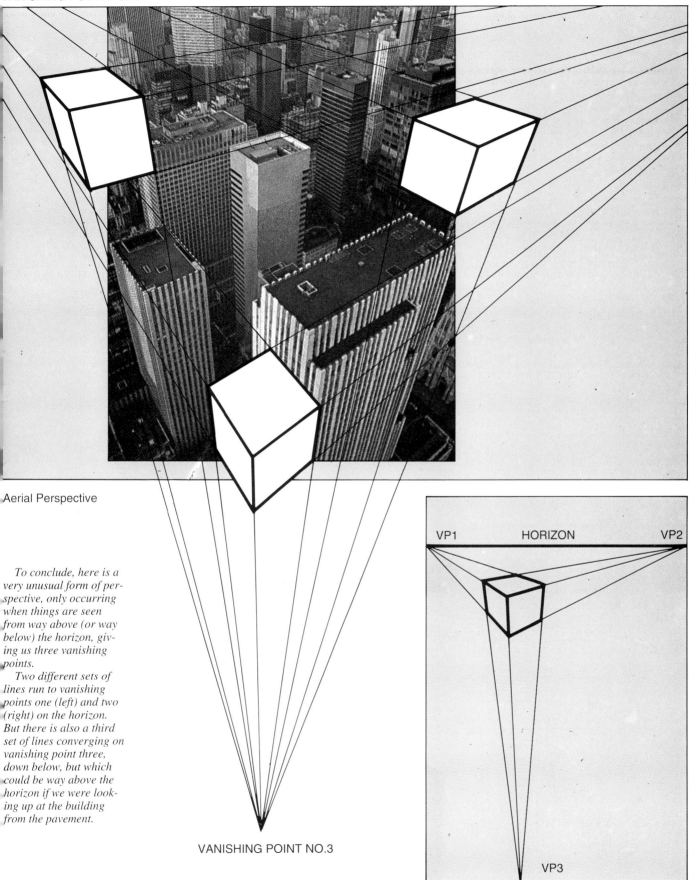

Aerial Perspective

To conclude, here is a very unusual form of perspective, only occurring when things are seen from way above (or way below) the horizon, giving us three vanishing points.

Two different sets of lines run to vanishing points one (left) and two (right) on the horizon. But there is also a third set of lines converging on vanishing point three, down below, but which could be way above the horizon if we were looking up at the building from the pavement.

VANISHING POINT NO.3

VP1 HORIZON VP2

VP3

Using perspective in the outline sketch

If we seem to be laboring the point that drawing is based on geometric shapes, it is not because we enjoy theorizing, but because it is quite true and has an undeniable practical value.

Find out for yourself: analyze the structure of any object you see, whether you are indoors, in the street, or in the countryside; whether it be a chair, a car, a flower pot, or a tree. You will see that all these structures can be reduced to spheres, cubes, and cylinders.

So, in theory, if we can draw these three things, we can draw anything!

Well, don't get carried away—unfortunately this is only in theory. In creative drawing, indefinable factors like personality, sensitivity, good taste, and emotion play a vital role. What is undeniable is that an awareness of theory (including perspective) gives the artist something on which to base his or her first efforts and also to help the artist apply reason (or common sense) when evaluating later work.

We will now demonstrate how helpful our early lessons in perspective can be when setting up a drawing and adjusting the angle of this or that line so it runs to the right vanishing point. Look at the example on this page: Even the freshest beginner can see that the general shape of the coffee grinder fits perfectly inside a cube seen in oblique perspective, from our point of view. A circle seen from the same viewpoint and forming the base of the hemisphere is the lid—do you see? A few more curved strokes (not forgetting your perspective) will give you the handle of the machine.

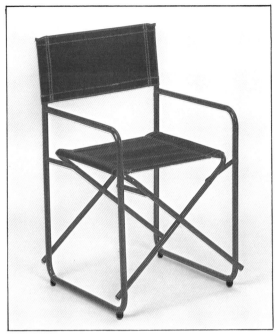

This chair and the coffee grinder on the previous page confirm that all objects really can, just as Cézanne said, be based themselves on a cube, a rectangular prism, a cylinder, a pyramid, a cone, or a sphere. Try it out with lots of examples that, like our chair, require the construction of squares at different heights, parallel to the base of the main prism. Don't forget that all vanishing parallel lines will run to a single horizon.

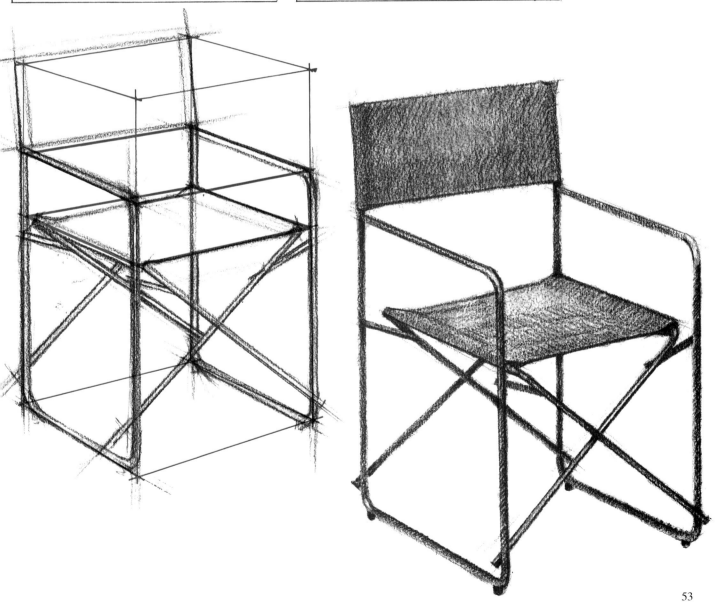

Describing the basic form of this jug has involved the assembly of various geometric lines with which we will need to become familiar if we want to construct anything with a round or circular shape. Once we have mastered these techniques, which mainly consist of constructing, in perspective, a cube, a cylinder, or a sphere from a square base, we can begin to work freehand.

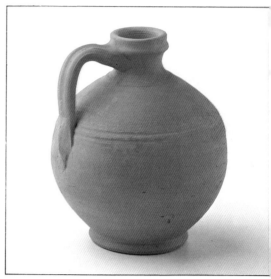

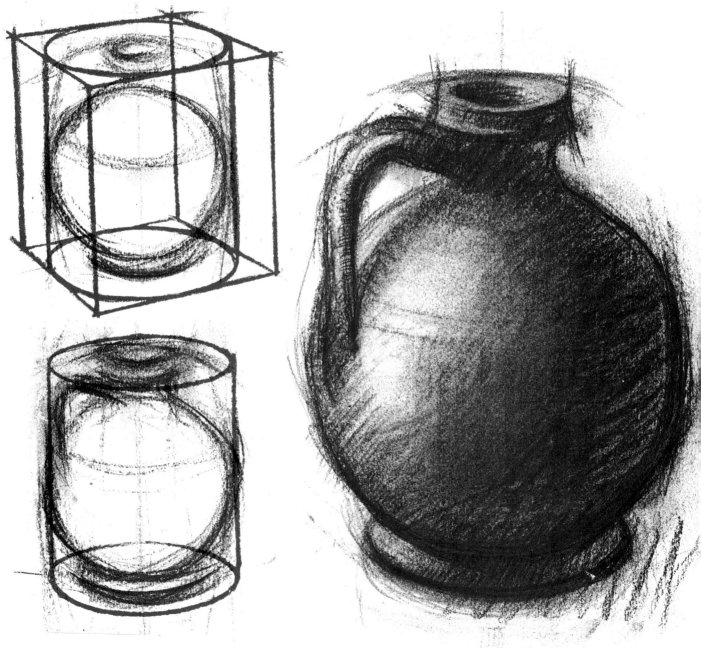

This antique coffee grinder is based on a simple structure that is easy to identify. Notice that the sketch is based on using a rectangular prism, a square, and a cylinder as the main shapes in an oblique perspective.

This picture, with the lively, familiar lines of the boat, is a perfect subject to demonstrate the use of basic forms in setting up a drawing— as is the example of the antique gas-lamp on the next page.

Notice how a prism in oblique perspective establishes not only the proportions of the object, but also the direction of its principal lines. The keel coincides with the line dividing the prism in half (in perspective) and the port and starboard sides of the boat are curves at a tangent to the sides of the prism.

Obviously, we can indicate on the basic prism as many point and construction lines as we like to help us set up the outline sketch of our subject. This is something the experienced artist often does along the way, at those moments when he needs to back up his intuition with a little theoretical know-how.

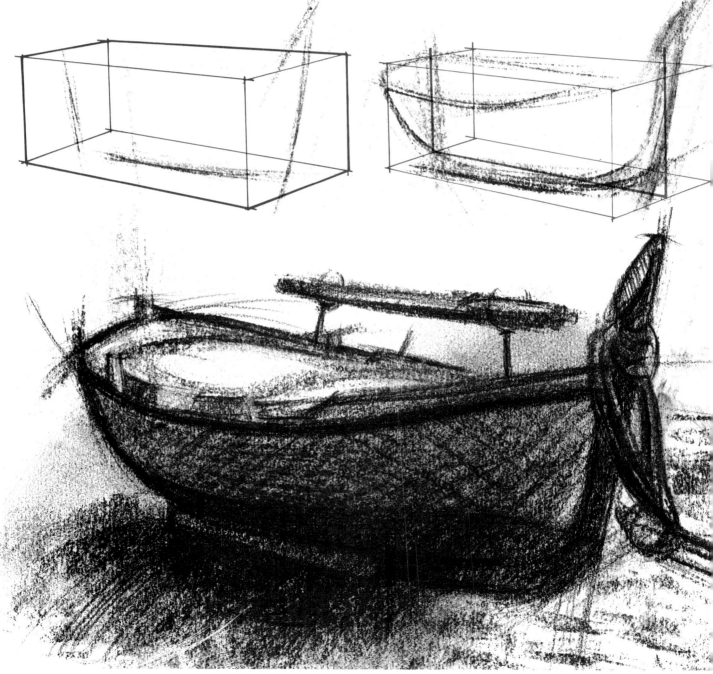

This gas lamp with its sparkling reflections, is made up of forms such as a cone, cylinder, a circle, and so forth. In conjunction, these create a structure that can be contained within a square prism. In the example, it is drawn in parallel perspective. Once the prism in parallel perspective is drawn, its center is found. Squares at various heights are drawn in perspective, within which are situated the circular forms that will give us the cylindrical shapes. On top of this sketch, some early lines are then roughed in to give us a clearer vision of the basic structure of the lamp.

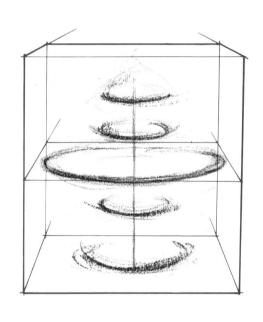

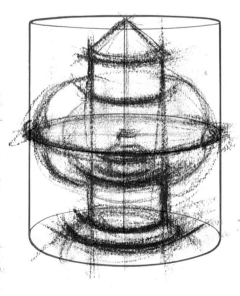

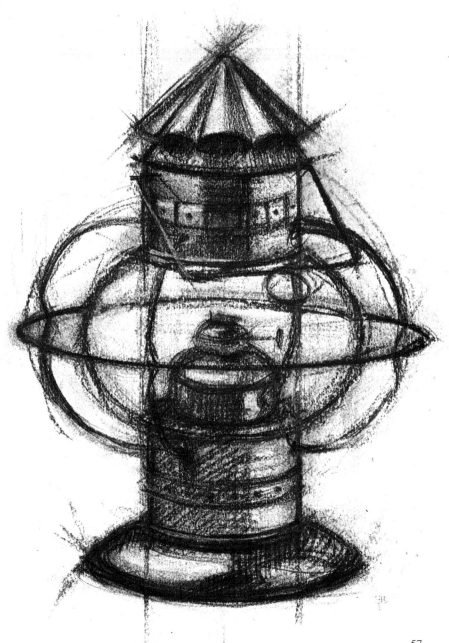

Let's take a more complex example in which, as before, the drawing is based on a perspective rendering of certain forms. This time, however, the forms will be of varying proportions and situated at different degrees of depth on the horizontal plane (also known as the gound plane). Notice, also, how the combination of the various forms drawn in oblique perspective fits perfectly inside a rectangle of simple dimensions.

The viewpoint from which we observe the subject places the horizon very near the top of the vase and bottles, which is why they are seen with very few curves. The closer our viewpoint to the ground plane, the more "open" the upper circles will appear in perspective.

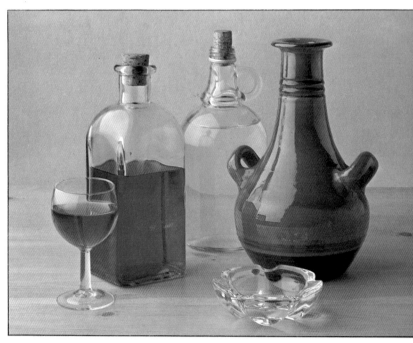

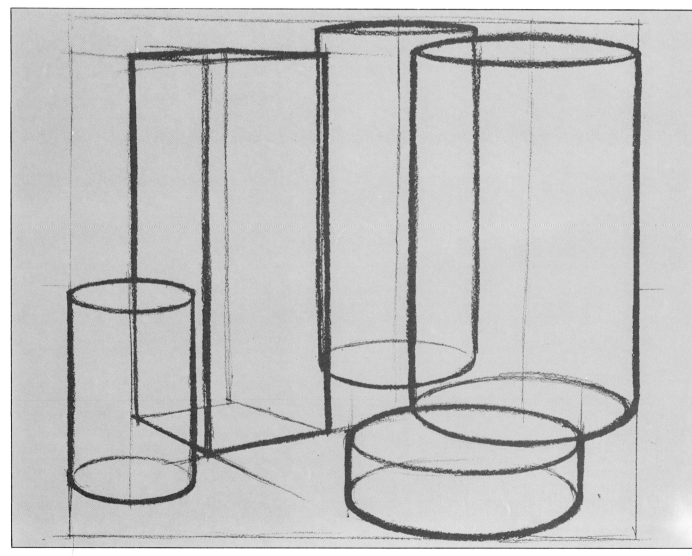

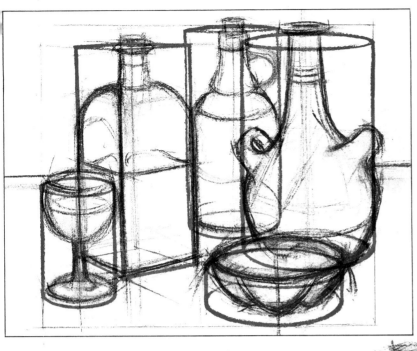

Another illustration in black pencil showing how different objects can be seen in terms of certain basic shapes drawn in perspective, as seen on the previous page. Notice how the "intermediate" circles and squares conform to the law of vanishing parallels. If you draw the vanishing parallels corresponding to each one, you will find that they converge at the same vanishing points as those of the basic prism and cylinders in the outline drawing.

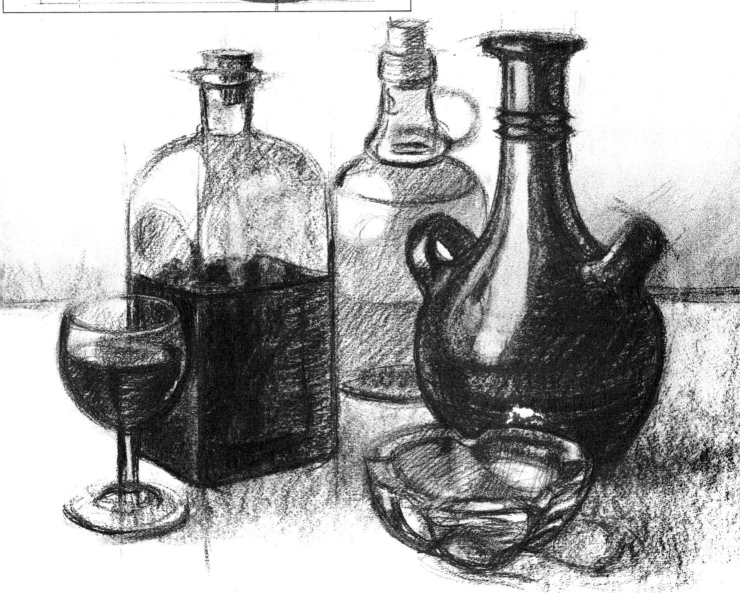

Calculating depth in perspective

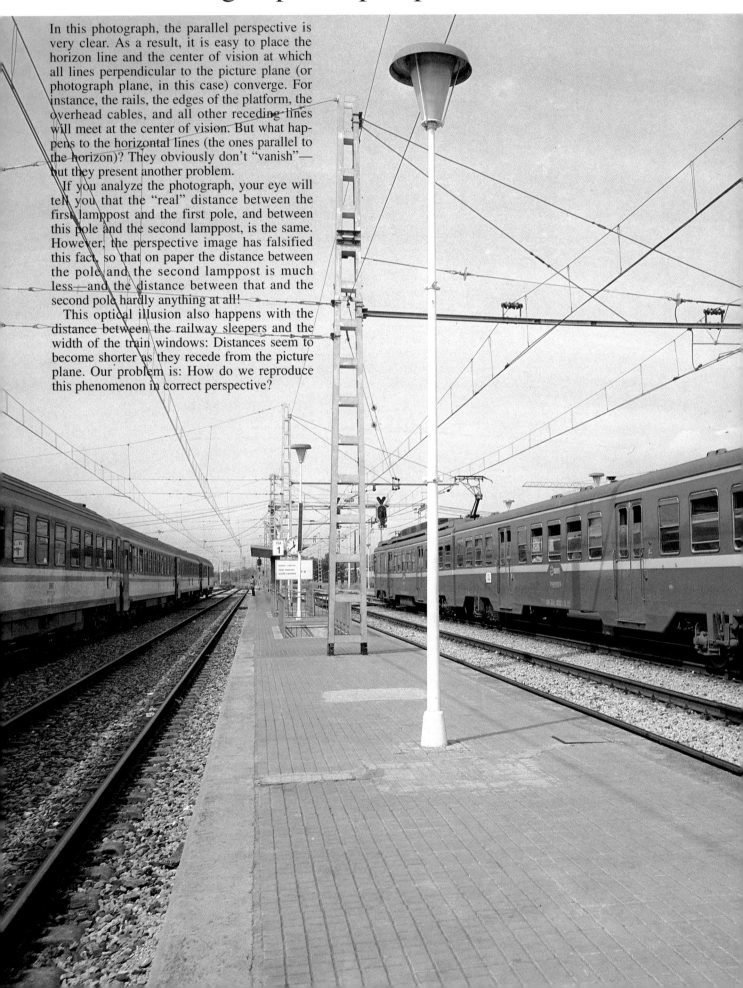

In this photograph, the parallel perspective is very clear. As a result, it is easy to place the horizon line and the center of vision at which all lines perpendicular to the picture plane (or photograph plane, in this case) converge. For instance, the rails, the edges of the platform, the overhead cables, and all other receding lines will meet at the center of vision. But what happens to the horizontal lines (the ones parallel to the horizon)? They obviously don't "vanish"—but they present another problem.

If you analyze the photograph, your eye will tell you that the "real" distance between the first lamppost and the first pole, and between this pole and the second lamppost, is the same. However, the perspective image has falsified this fact, so that on paper the distance between the pole and the second lamppost is much less—and the distance between that and the second pole hardly anything at all!

This optical illusion also happens with the distance between the railway sleepers and the width of the train windows: Distances seem to become shorter as they recede from the picture plane. Our problem is: How do we reproduce this phenomenon in correct perspective?

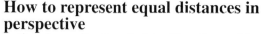

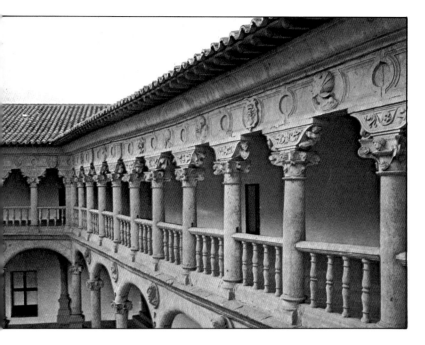

How to represent equal distances in perspective

Let's take a situation that typifies the problem we are facing: We have to represent, in perspective, the apparent separation between the columns in the upper gallery of these cloisters. In this and similar cases (telegraph poles, equidistant trees, and so forth) the following system is very useful:

1. Once you have situated the horizon and the most important receding lines, draw in, using your eye for measurement, vertical lines representing the first two columns, as if these defined the depth of a vertical rectangle drawn in parallel perspective. When you feel the distance AB is accurate, draw the diagonals of your rectangle AA'BB' in perspective and a vanishing parallel that passes through the intersection of these diagonals. This vanishing parallel will intersect the axis of the second column at point 1.

2. From A, draw a straight line passing through point 1 to create C. This straight line is, in fact, the diagonal of a rectangle whose depth, AC, is twice AB. Therefore, the distance BC is equal to AB—in perspective, of course. What next? Simply continue the process drawing diagonals that successively determine points D, E, F, and so forth, representing the axes of the different columns.

3. Look at the more finished version of the drawing and consider how such an elementary perspective construction has enabled us to produce an accurate impression of the space between equidistant objects.

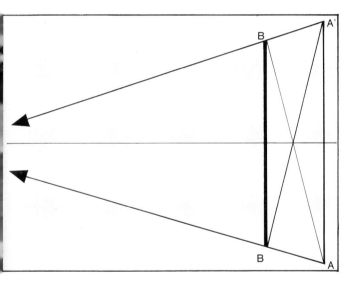

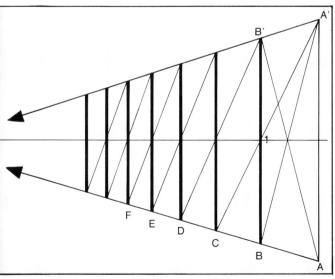

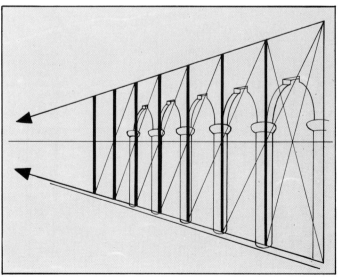

A grid in perspective

In parallel perspective

The width of the individual squares is indicated on the front edge of the grid. From these points, vanishing parallels lead to the center of vision. In the right-hand corner, the depth of a square with sides measuring "three-by-three" units is determined. The extended diagonal of this square cuts through the vanishing parallels at points 1, 2, 3, 4, and the like, which establish the depth of the successive rows of squares. This process could be continued ad infinitum.

In oblique perspective

A. A measuring line is drawn with a series of divisions equal to the measurements of the segments. A diagonal **D** is drawn to point **d**, which marks the vanishing point for the diagonals. Vanishing parallels are taken to a point off to the left allowing us to establish depth scales at 1, 2, 3, and 4.

B. From these points vanishing parallels are traced to a point off to the right and extended forwards to complete a square of four-by-four segments.

C. Another diagonal drawn in perspective indicates new depth lines for parallels vanishing to the left, which cut through diagonal **D**, creating new marks for parallels vanishing to the right. In this way the grid is built up.

D. Continue the process until you reach the required depth of grid.

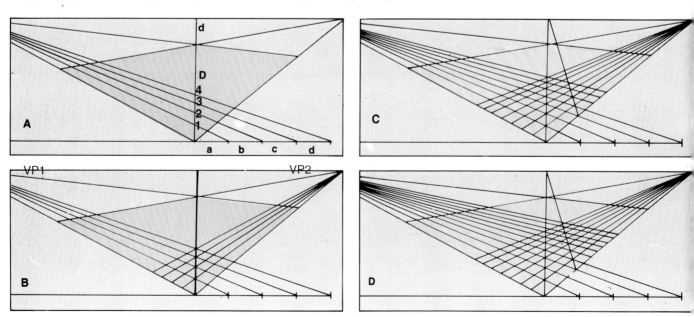

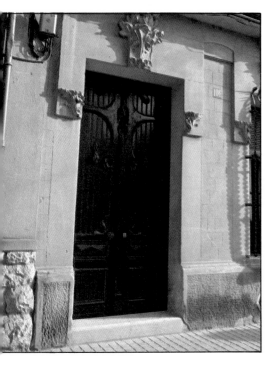

Left. The most practical way of finding the line that divides a rectangle or square in half in perspective, is to draw in the diagonals.

Below. Study by Leonardo da Vinci for "The adoration of the magi." The plan traced on the ground plane allowed this old master to know, at any given moment, at what level of depth each element of his complex composition was situated.

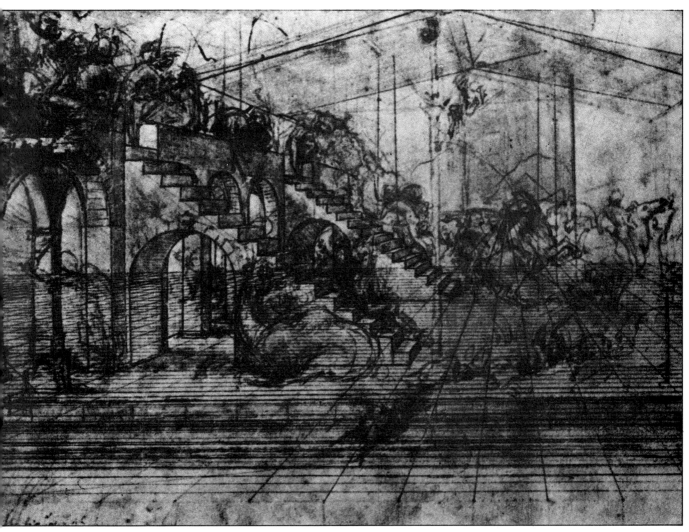

◼ Two examples

Above. In this imaginary neoclassical construction, the perspective artists confronted and resolved practically every problem that a parallel perspective might present. This is quite a display.

Below. A cloister in Barcelona Cathedral; reed pen drawing by M. Ferrón. In this oblique perspective, the depth has been established by diagonals applied free-hand or by trial and error, with the prior knowledge that accuracy would be relative. Absolute precision, in creative drawing, is of only limited importance.

Regular and irregular shapes in perspective

Drawing a grid is a useful exercise whenever we need to place anything in perspective, whether it be a regular geometric figure or a totally irregular shape or form. In every case, the problem can be reduced to let us see how to place in perspective the relative depth of different parts of the subject. Two typical cases are those illustrated on this page: A mosaic with triangular forms and a completely irregular shape (a flower) that, without the help of the perspective grid, would be very hard to describe in terms of depth.

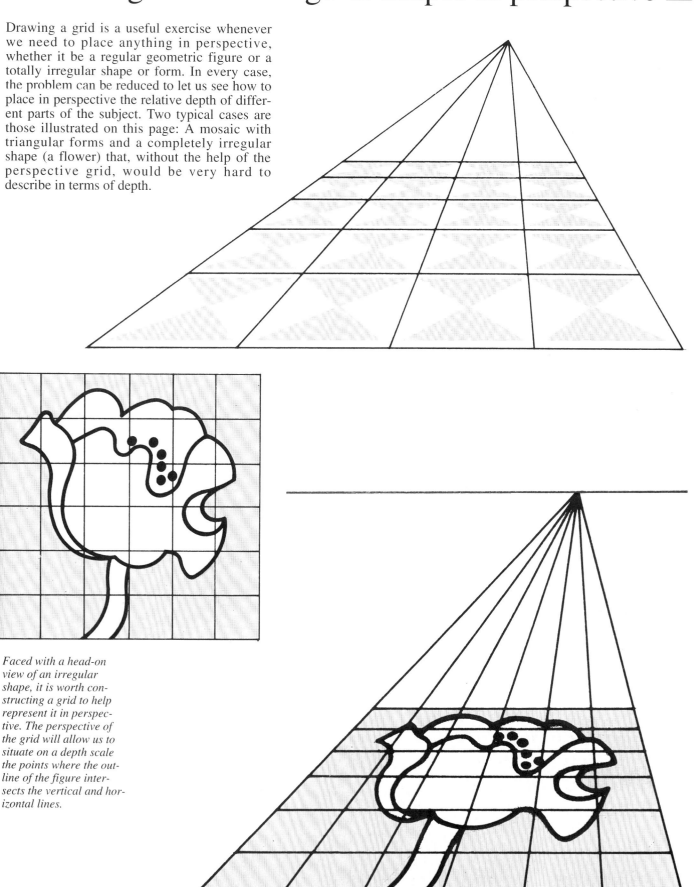

Faced with a head-on view of an irregular shape, it is worth constructing a grid to help represent it in perspective. The perspective of the grid will allow us to situate on a depth scale the points where the outline of the figure intersects the vertical and horizontal lines.

A practical example

Let us conclude these notions of perspective with an example that sums up all the elements we have studied until now. Study carefully the line drawings on top of which, in red, we have placed the horizon line and the vanishing parallel and construction lines that guided the artist in producing these perspectives. It would be interesting to trace this drawing to show that all lines that in reality are parallel really do run to the same point on the horizon—except, of course, for the vertical lines, which remain vertical and the lines parallel to the horizon, which do not have a vanishing point.

Drawings like these, produced in ink with watercolor wash, are frequently produced in architects' and interior design studios. The perspective drawing allows the architect or designer to show clients what their proposed designs will look like (a villa, in our example) before they have actually been built.

Below. In this diagram the measuring lines showing the distance between verticals can be seen, as can the lines receding to vanishing points VP1 and VP2. Another detail: Sloping lines A and B, which are parallel to one another, run to one point on the vertical that passes through VP2; VP2 is the vanishing point for horizontal lines on the plane comprising the lines in question.

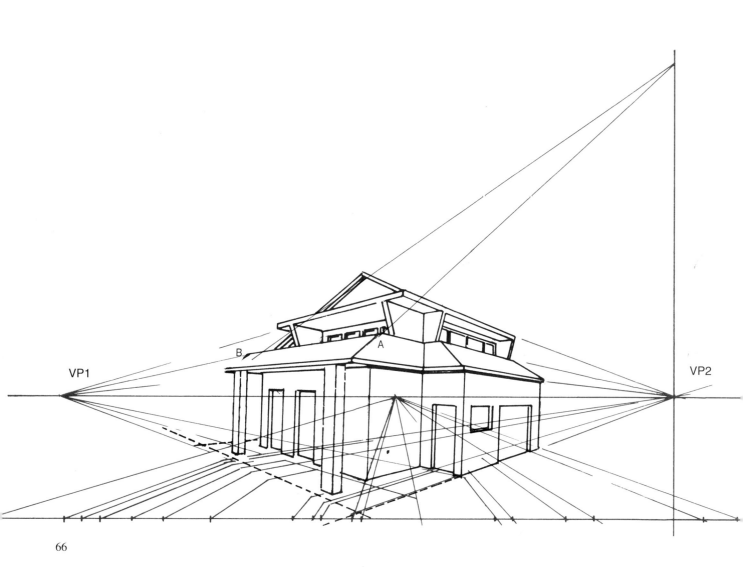

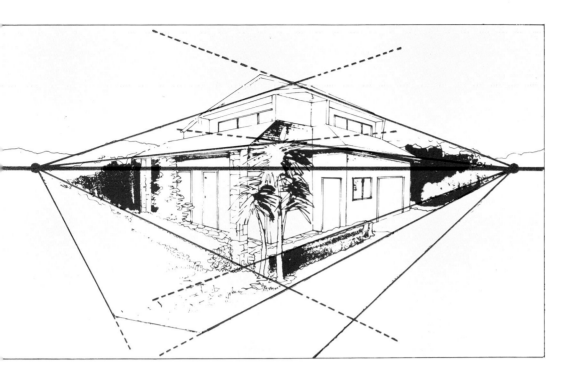

Left. On top of the pen and ink drawing we have superimposed the horizon line—which indicates to us that we are looking at the villa from a fairly elevated position—and the vanishing points, appropriate to an oblique perspective drawing, on which the two sets of parallel horizontal lines converge, on either side of the viewpoint.

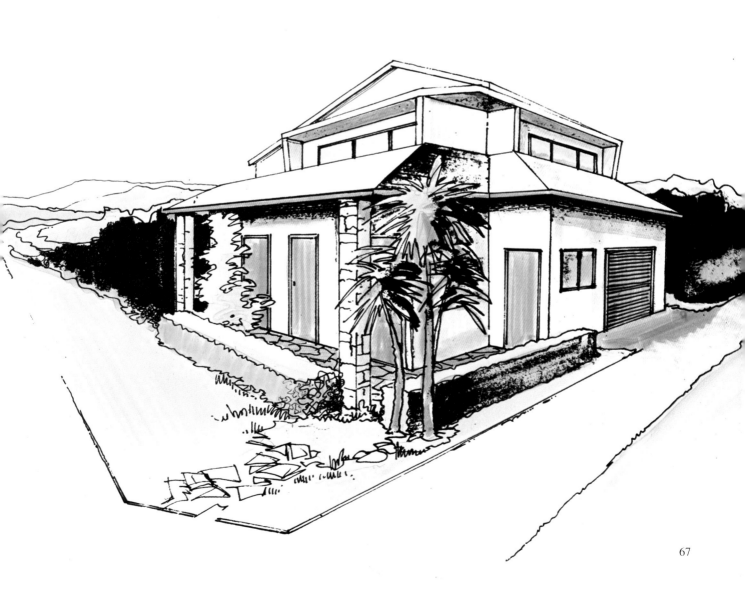

Drawing with charcoal

Charcoal is obtained by means of the controlled combustion of small twigs (willow, vine and walnut being the most frequently used). It is, without a doubt, one of the most ancient drawing materials known to man. But it was in the seventeenth century, with the advent of new types of paper better suited to showing the effects of light and shade, that charcoal came into its own as the primary technique used in training future artists.

Charcoal in its ancient and modern form, has many qualities that make it ideal for exploring chiaroscuro (the effects of light and shade). On the right paper (basically Ingres or cartridge papers), it can produce gradations ranging from total black to the white of the paper, passing through every imaginable shade of gray. It can be blended to wonderful effect using the fingers or a torchon or piece of cloth. For blocking in large surface areas with uniform tone, powdered charcoal can be spread evenly with a cloth or rag.

Another great advantage of charcoal is that white areas can be restored quite easily with an eraser; also a drawing can be altered during its creation by dusting off areas with a cloth. During this operation, the drawing does not disappear altogether, but is left in a state where you can build on the successful parts and rectify the less successful sections in the hazy images remaining on the paper. When drawing in charcoal as part of the academic process, the drawing is often partially erased at one point (generally after the initial sketch and the first blocking in of light and shade), after which the real study of light and shade begins, working the charcoal with fingers, torchons, and rags, as well as the rubber eraser—an important tool when using this technique.

It is hard to sharpen a stick of charcoal (even if it were possible, the point would not last), so it should not be used for small-scale work; it is not intended for miniatures. It is a technique much better suited to modeling form by means of chiaroscuro than to describing outline in minute detail.

The instability of charcoal as a medium is easy to demonstrate: Blowing hard removes all surface dust; if the paper is shaken, any pigment which has not penetrated the grain of the paper will fall off and, if a cloth is then applied, almost *all* the charcoal will be removed. However, you should not rely on this; in spite of its instability, to erase every trace of charcoal is an arduous, if not impossible, task. The darkest lines always leave a mark that not even the plastic eraser can completely eliminate.

Charcoal drawings need to be fixed with a liquid fixative applied with a mouth atomizer or using a special aerosol can.

Characteristics and techniques of charcoal

The application and fixing of charcoal
Charcoal is a very unstable medium and the slightest touch can remove the top layer of pigment. As a consequence, you must not work with your hand resting on the paper.

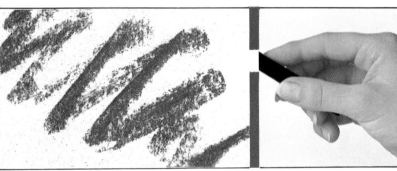

For blackening, shading or gradating, it is best to work with a little piece of charcoal rather than with a long "stick." Try to form a wedge shape on the edge in contact with the paper so you can produce wide, even strokes.

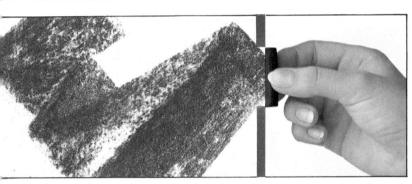

When covering large areas, the charcoal (or a piece cut to a convenient size) can be applied "flat" onto the paper. By varying the pressure applied, gradated strips of gray can be produced to great effect.

Charcoal drawings must be fixed. To do this, place your drawing on a board and cover it with liquid fixative applied with an atomizer. You'll need a good pair of lungs to use the mouth atomizer.

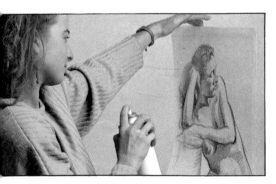

Aerosol cans of fixative are more expensive but much more practical and reliable, allowing for a more even distribution of the liquid. Whichever method you use, several layers of fixative must be applied, each time waiting for the previous layer to dry. The number of layers required will depend on the amount of black pigment in your drawing. Normally, three layers are sufficient.

The instability of charcoal
A good part of the char-coal dust present in the sketch (A) has disappeared after being rubbed with a cloth (B). However, the lively strokes remain, enshrouded in a "mist," and they can be used as a base.

The instability of char-coal can be seen when you run your finger across a patch of black, turning it into a blended gray (A). If you blow hard on a black patch, part of the dust will be removed. This changes the tone to a dark gray (B).

Using the eraser
If you use an eraser instead of your fingers, the width of stroke and the tone of the highlighted area can be more easily controlled (A). In B, an even lighter area has been created by two applications of the eraser.

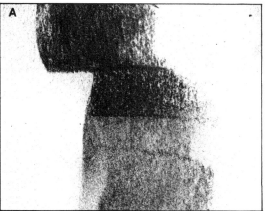
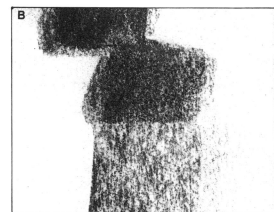

By molding a rubber eraser into a conical shape (like the tip of a pencil) or a wedge shape, it is quite easy to create "negative" details (A) by removing charcoal dust. However hard we rub with a plastic eraser, the dust that has adhered to the paper will never completely disappear.

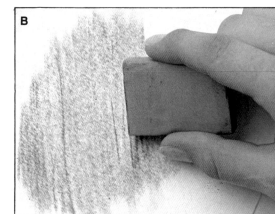

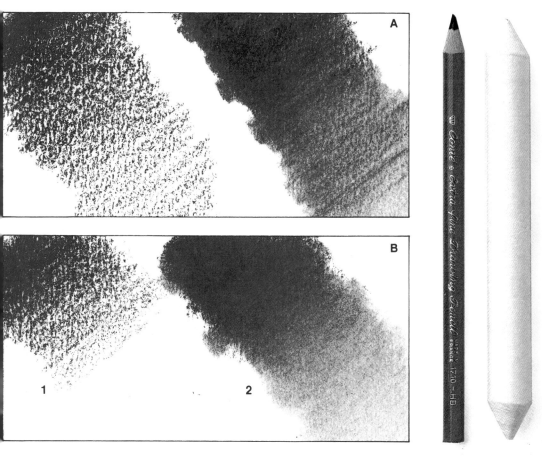

Gradations using a charcoal pencil and a torchon
Notice (A) that a charcoal pencil gradation darkens considerably when it is blended. To achieve a gradation that goes from black to a fairly pale gray in a short space (B), start with the pencil (1) and then work on this initial area with the torchon (2).

Drawing a sphere in charcoal

Drawing a sphere using charcoal and your fingers is a good way of exploring the subtle effects of light and shade that this medium offers.

1. With firm strokes, draw the outline and the areas of shade and projected shadow.

2. Using your finger, spread the black pigment, molding the shape of the sphere and lightening the tone towards its brightest area. Try not to darken this point too much. Also blend and soften the shadow of the sphere.

3. Reinforce the darkest area with more charcoal and soften the outer edges of this new tone. With a clean finger, take out some pigment from the areas around the brightest spot and also around the darkest part of the sphere, so as to convey the faint strip of reflected light. Clean up the background.

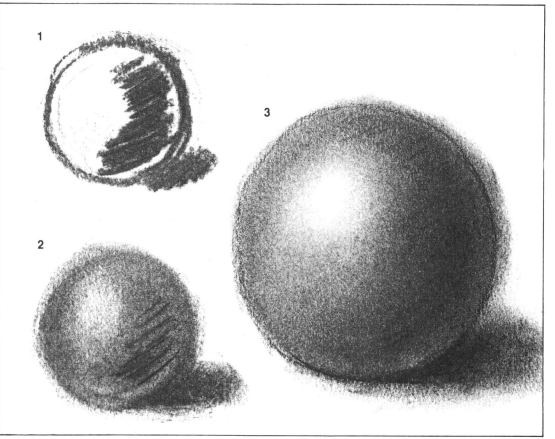

Four examples

1. Figure study by Juan Sabater, based on the subtle manipulation of large areas of charcoal.

2. A mixed media drawing by J. Juan Aguera, in which charcoal was used in part.

3. Another drawing by Sabater, in which again he builds up structure in large planes of pigment.

4. Classic preliminary sketch for a study of a moving figure: Drawing by Ester Serra.

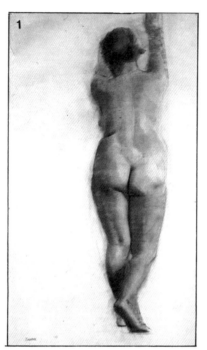

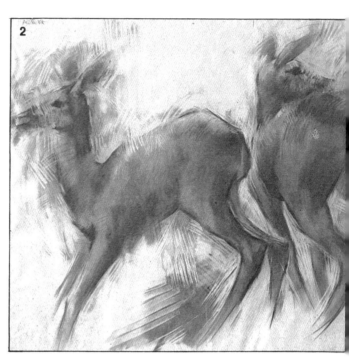

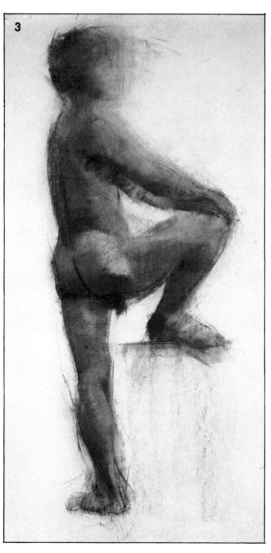

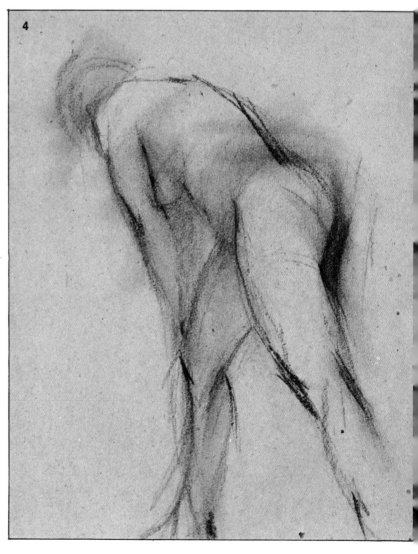

Charcoal drawing using a plaster-cast model

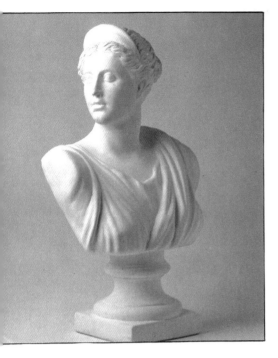

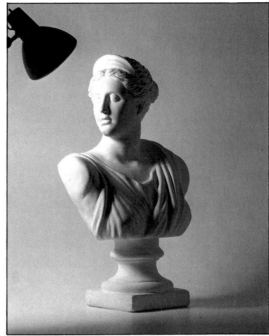

This art school exercise is initially concerned with the lighting of the model. How should it fall on the figure? In our example, natural light comes from the left; it hits the model very much from one side and produces a wide range of tonalities. When a powerful spotlight is used, the contrasts are accentuated but many subtleties of tone are lost, so we have decided to work with natural light.

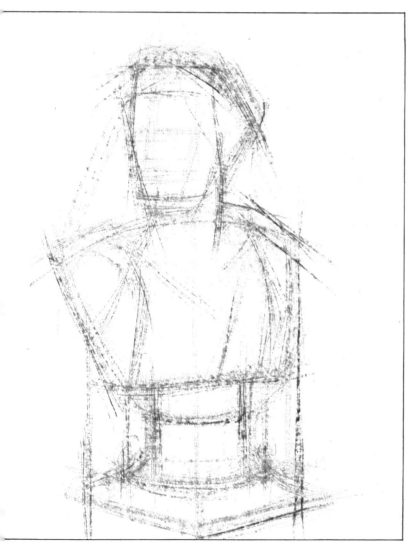

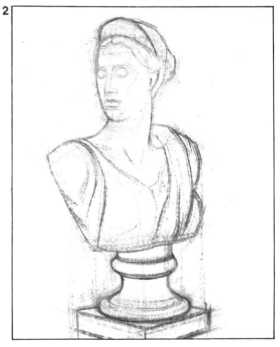

1. We begin by outlining the figure, in charcoal, reducing the lines to the bare essentials. Although nothing has been described specifically, everything we need to continue the drawing is there such as volume and proportions.

2. Once we are satisfied with our outline drawing, we can rub over it with a cloth to get rid of the dust, leaving just the basic lines on the paper. From these, the definitive outlines will be built up.

Charcoal drawing using a plaster-cast model

3. At this stage, a first layer of tone is added to clearly establish the areas of light and shade, but using only intermediate tints. We move from the white of the paper and half-tone shadows through various transitional shades. We will be able to add the more vigorous tones later, but at this point it is important to build up the structure of the model perfectly without resorting to the darkest tonal values. Remember that it may be necessary to make corrections, either to lines or shading, something that is no problem if you have not used heavy or dark lines that are impossible to erase.

4. We are now entering the final stage, which consists entirely of introducing the areas of light and shade. It is assumed that, by now, the basic lines and shadows of the drawing will all be in place. From the moment we have completed the initial blocking in of tone (stage 3), we should regard the drawing as unalterable. The final stage involves four aspects of charcoal technique that we have summed up for you in the photographs below:

3
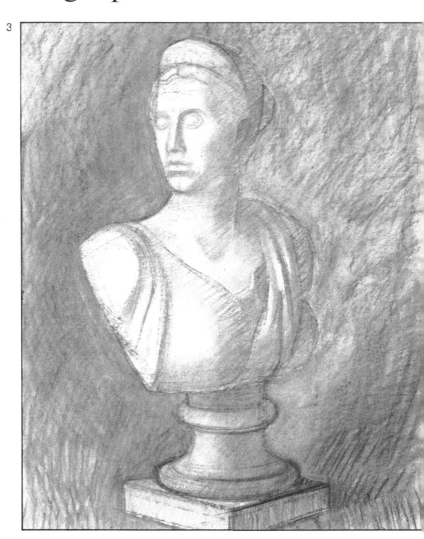

A. The dark areas are intensified using nothing but charcoal.

B. The highlights are cleaned up and sharpened with an eraser.

C. A cloth is used to smooth over the gray areas that require a uniform, medium tone. If necessary, the areas that look too black can be lightened in this way.

D. The areas of transition between light and shade are blended with the finger or a torchon. As we began this exercise without blending the background areas, we will try not to use this technique excessively at this point, either.

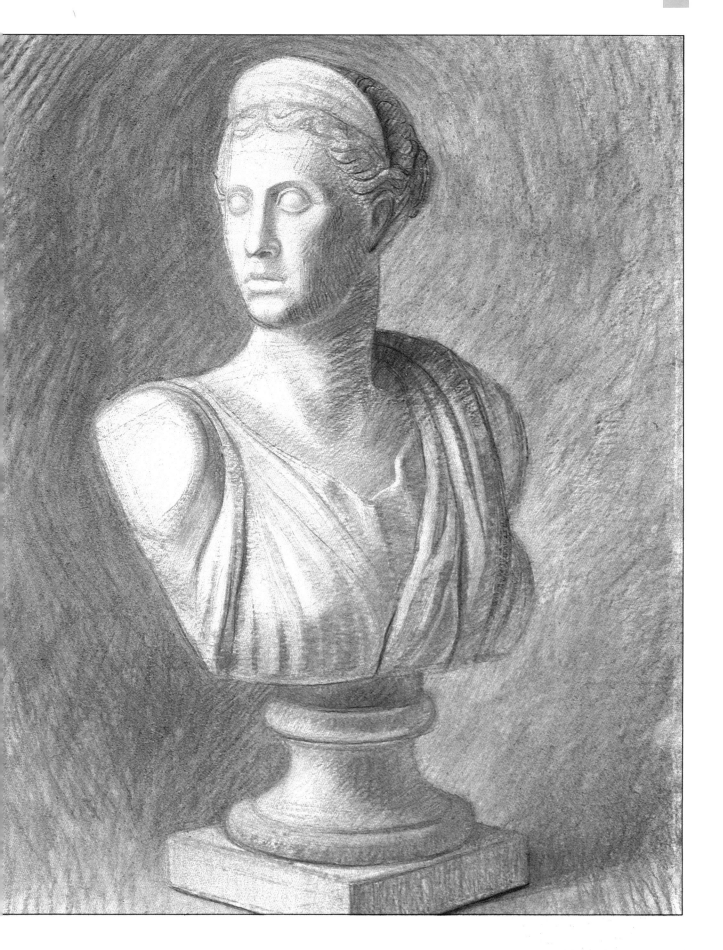

Pen and ink drawing

Drawing with pen and ink is one of the most ancient techniques known to man. The original implements used were basic compared with the metal pens we use today, and even more so in comparison with the reservoir pens and felt-tips that have become so popular in the last few decades. For many centuries, great artists used reed pens and goose, swan, or crow feathers. The metallic nib appeared at the end of the eighteenth century, and is still widely used.

In modern times, what we call pen and ink drawing comprises no fewer than twelve techniques that involve drawing with line and patches of ink or dark color, without half-tone or even gradations.

The traditional pen and ink nib is narrow and flexible and can be fitted inside a wooden holder. There are, of course, many other nibs (flat, blunt-ended, round-ended) that can also be used in the holder. Many people like to draw with fountain or reservoir pens and ballpoints, which are very useful for producing even lines of uniform thickness.

Reservoir pens that take cartridges are useful in that they offer a great variety of interchangeable tubular nibs.

Felt and fiber tip pens, with their variety of textures and thicknesses, have some characteristics in common with their more traditional counterparts.

Although we begin by looking at drawing with different types of pens, we should not forget that brushes are very useful for blacking out large areas.

However, in spite of the considerable advantages of reservoir pens and felt tips, the techniques that to this day offer the greatest expressive possibilities continue to be the classic ones: Drawing with a dip or mapping pen, or a reed pen, all of which produce extremely fine and sensitive strokes as well as bold, dark strokes of high quality.

As for ink, the most widely used is black Chinese or Indian ink, available in little pots that make it easier to load the pen, without needing to transfer ink from one container to another. If you wish to work with diluted ink, buy ink sticks that can be dissolved in water. However, this is moving more towards the technique of line and wash as opposed to traditional pen and ink drawing.

1. Drawing produced with a metallic nib. There is no complicated network of strokes; the contrasts are provided by a series of lines and black areas.

2. Detailed pen and ink drawing. This is a technique that requires, as well as great drawing skills, a good deal of patience.

3. The great Renaissance masters, like many other artists, used pen and ink. This is a "David" sketch by Michelangelo.

4. "Hands at prayer," a famous pen and ink drawing by Albrecht Durer, using black and white ink on blue paper. It seems incredible that this wonderful work was drawn with a reed pen or goose feather.

Tools

In our introduction we referred to the different implements used today for drawing with Chinese or Indian ink and that can be described generally as tools for pen and ink drawing: These include traditional dip pens, felt tips, fountain or reservoir pens, reed pens and the like. The following list refers to the selections illustrated on this page.

Right

1. Nib for dip or mapping pen.
2. Nibs of various thicknesses.
3. Wooden pen holders.
4. No. 6 sable brush.
5. Scraper-board nib for working on coated paper.
6. Fountain pen.
7. Reservoir pen with tubular nib.
8. Fine felt tip pen.
9. Wedge-nibbed marker pen.
10. Brush handle adapted for use as a pen and ink tool.
11. Bamboo cane shaped into a nib.
12. Cane cut into a wedge shape.
13. Small reed cut into a wedge.
14. Wedge of wood.

Below. Turning a piece of bamboo cane into a tool for pen and ink drawing.
a) Creating a point.
b) A longitudinal cut gives the nib flexibility.

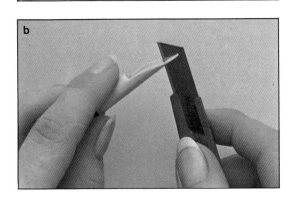

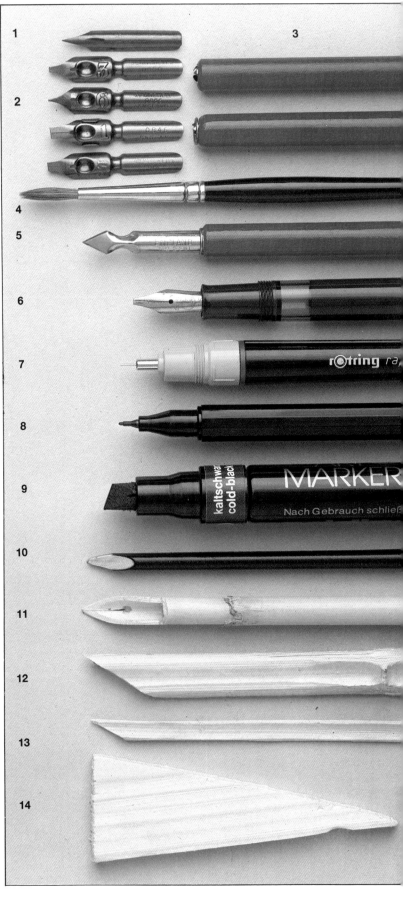

Sample strokes

Black lines produced with a dip pen and Chinese ink.

White lines drawn in white ink with a dip pen on a black background.

a) Individual strokes drawn with a fine nib and *b)* with a blunt-ended nib. The thickness of line varies according to the angle of the nib.

a) Brush strokes of varying thickness and intensity. *b)* White lines drawn with a scalpel on coated paper previously covered with black ink.

a) Wavy lines drawn with a fountain pen. *b)* Fine, regular lines drawn with a reservoir pen.

a) Lines of different thicknesses produced by a wedge-shaped marker pen and *b)* cross hatched lines made by a fine felt tip pen.

a) Thick, black lines and semi dry strokes drawn with a nib cut from a piece of cane. *b)* Fine lines and semi dry strokes drawn with the tip of a brush handle.

a) On a gray background, thick and fine strokes drawn with a piece of cane cut into a wedge and *b)* stripes and strokes produced by a wedge of wood.

Techniques

A. Different strokes using a dip or reservoir pen.
B. Drawing produced with a dip pen.

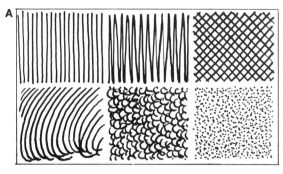

From left to right: Parallel lines, zig-zag lines, cross hatching, curved lines, circular strokes and pointillistic shading.

Simple example of how the metal nib can create depth and shade with strokes that carefully describe and define form.

C. Pen and ink drawing carried out with a reservoir pen and a mapping pen.
D. Drawing using the pointillistic technique. Reservoir pen on coated paper.

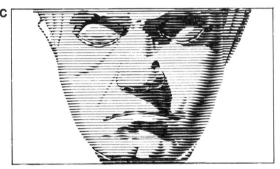

First a pencil drawing is made paying attention to tonal values. The reservoir pen draws a pattern of fine parallel lines. With a metal nib, the shading is added.

First a pencil drawing carefully maps out the shading. The dots, made all the same size with a reservoir pen, are more densely applied in the darker areas.

E. Line drawing. Dip pen, ball point, reservoir pen, or fine felt tip.
F. Drawing with white ink on a black background.

Pure line drawing, without shading, requires exceptional mastery of form. This technique has been used by great artists such as Picasso, Matisse, Renoir, and Dali, among others.

This technique is carried out on black card or previously tinted paper. White ink, applied with a pen or brush, is used to situate highlights and describe form.

G. Negative drawing imitating the style of a woodcut.
H. Block style pen drawing.

Drawing in negative can be done on a strong piece of card; the card is painted with Chinese or Indian ink and whites are opened up using a scalpel or sharp pointed blade.

The block style does not allow for half-tones. The forms are described by means of blocked, black areas (shadows and dark tones) that contrast with the white of the paper.

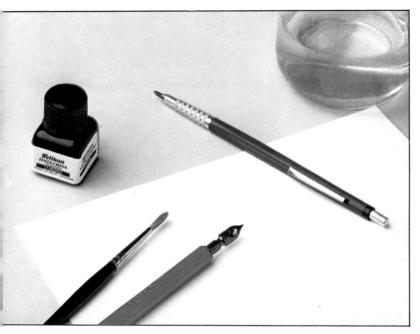

A suggestion

Choose a photograph you like—perhaps showing a corner of one of these little villages that seems to have been designed especially for pen and ink artists to show off their skills. Make a study of this photograph in pen and ink. But, how...? Well, however you think best: By means of a variety of strokes, or perhaps by putting your patience to the test with the pointillistic style, or by using the parallel line technique, by combining pen and paintbrush (for large, black areas), and so on. To inspire you, we are going to show you a drawing by Sabater, produced using the materials you can see on the left: A bottle of Chinese ink, a metallic nib, a clutch pencil, a No. 4 brush, water, and, of course, a sheet of good quality coated paper, not too large—7 × 9 in. (18 × 23 cm) is big enough.

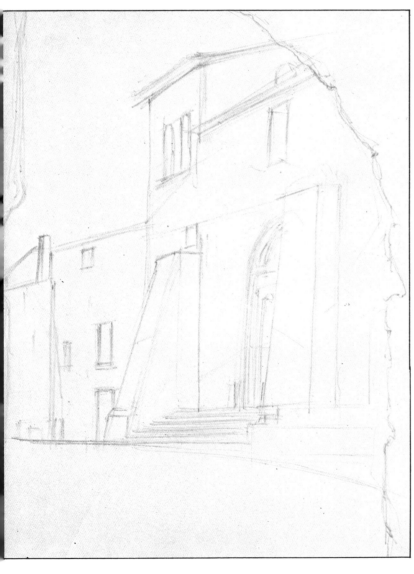

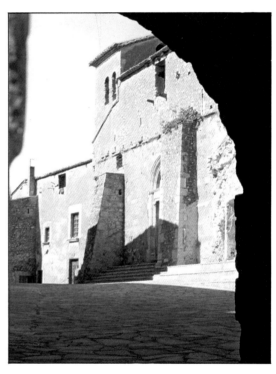

1. Pencil sketch

From his chosen photograph (which you can see above), the artist has made a pencil sketch, using just lines, in which he has resolved the proportions and perspective of the subject. By the time he starts to apply the ink, all doubts concerning these aspects of the drawing must have disappeared. From now on, the only obstacles to contend with should be purely technical ones.

Pen and ink exercise

2. The darkest areas

Sabater has worked mainly with a pen, but he has consigned to the paintbrush the task of covering the largest areas with their base tone. With the brush well-loaded with ink, the part of the arch in the extreme foreground has been blocked in. The brush has applied a layer of intense black in this area, going on to other parts of the drawing with slightly drier ink, so that in these subsequent areas there is still room for work with the pen.

3. Using the pen

With purposeful strokes, the metallic nib has defined the different areas of the drawing, including the sky. The darkest areas have been worked on (on top of the shading of the previous stage) with a pattern of strokes that have created texture and contrasts. Through a balance of the tonal values and texture of the individual facades of the buildings, Sabater has achieved two things: Enriching the drawing and also bringing out the luminous quality of the building in the background, which, in the finished drawing, contrasts clearly with the foreground and middle ground, both of which have been more intensively worked and, therefore, darkened.

"Focusing" the light on a background area does nothing to detract from the feeling of depth in the drawing. The black areas are strong enough to project the foremost planes; and the strip of light that flashes across the ground plain carries the eye from the foreground on the right to the deepest background of the picture.

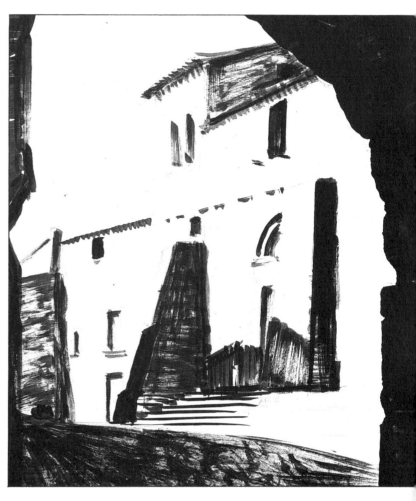

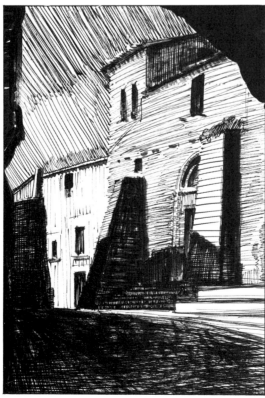

Right. Appearance of the drawing after the first pen strokes and detail of the action of the pen on the church steps.

Opposite page. The finished drawing, after the facade of the church, the ground and the dark areas framing the background building have been strengthened.

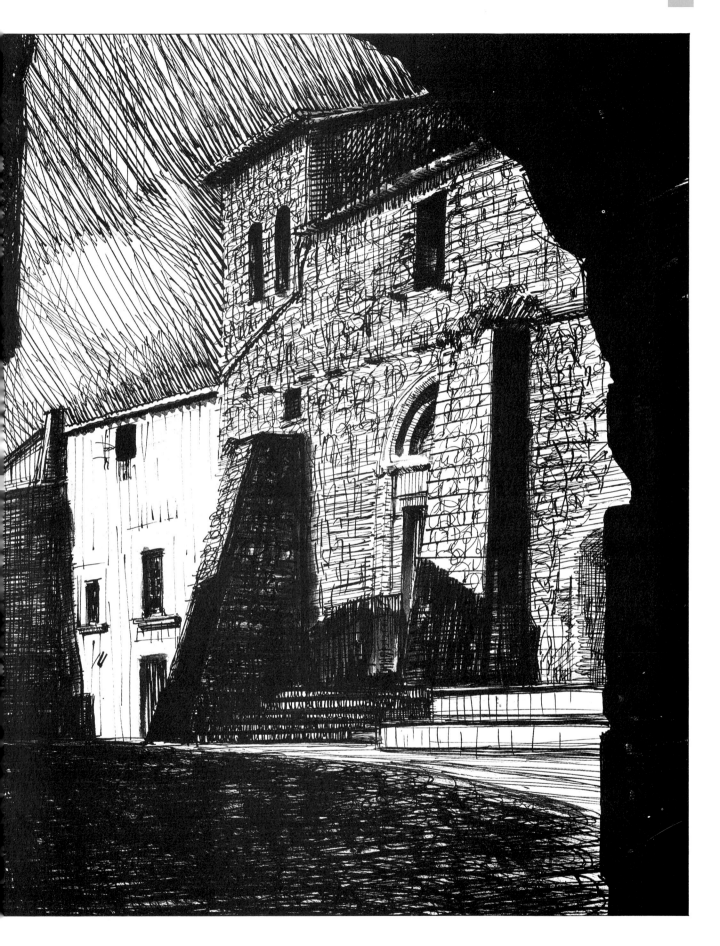

Drawing in ink with a paintbrush

A sable, or similar type of brush, used skillfully, can be an extraordinarily sensitive and versatile drawing implement. Many illustrators and strip cartoonists prefer the brush to the pen; it is more flexible and allows for a freer style. The versatility of the brush as a drawing tool is a direct consequence of the quality and shape of the hairs. For instance, round brushes of sable, squirrel, or synthetic hair can produce an incredibly fine line or a stroke as wide as the thickness of the brush.

It is also possible to take advantage of the ever-decreasing strength of the stroke, as the brush uses up its load of ink. The total black produced by a heavily loaded brush gradually becomes a paler and paler gray, until it is no longer sufficient to slide the brush across the paper; to keep making an impression, considerable pressure must be applied, creating some really subtle and transparent grays. This technique, properly executed, is sometimes known as the dry brush technique and, as we will see shortly, offers a wide range of possibilities. When using the brush (especially if it is heavily loaded with ink), it is impossible to hesitate. As soon as it touches the paper, there is no going back. You will discover this as soon as you try it out for the first time. In view of this, it is not surprising that aficionados of this medium are usually skillful draftsmen, especially those who apply it to figure drawing.

Each of us knows our own limitations, but our recommendation is to avoid the human figure as a subject when first using a brush and Chinese ink. It is better to go for a landscape or simple themes: Rustic buildings, for example, without too many complicated forms and with clearly defined contrasts of light and shade. Although a landscape, like any subject, must be drawn correctly, it never requires the same precision as the human figure. Another useful subject is the still-life, in which the most unlikely objects can be combined: Fruit, vases, books, metal and glass objects, and so on.

2

1. "Head of an old man" by J.M. Parramón. In this portrait, the artist shows his mastery of the dry brush technique, in the intermediate gray tones as well as in the strokes that soften the outline and lend atmosphere to the drawing.

2. "Nude study" by M. Ferrón. In this quick sketch, using continuous brush strokes, Ferrón shows his great skill in figure drawing.

3. "Rural theme" This landscape, drawn in ink with a brush by Juan Sabater, is reminiscent of an etching in its subtlety.

Materials and techniques

Brushes

Right. *Four types of brushes suitable for ink drawing. With the exception of the hogs' hair brush (useful for covering large areas and for obtaining uniform grays when using the dry brush technique), these are all extremely versatile, producing fine lines and even or variable strokes, depending on the pressure exerted. For normal work, two round, pointed brushes (preferably sable) are generally enough, the size of which should depend on the size of the work; in addition, a flat hogs' hair brush of the appropriate size is useful for feathery, dry brush effects.*

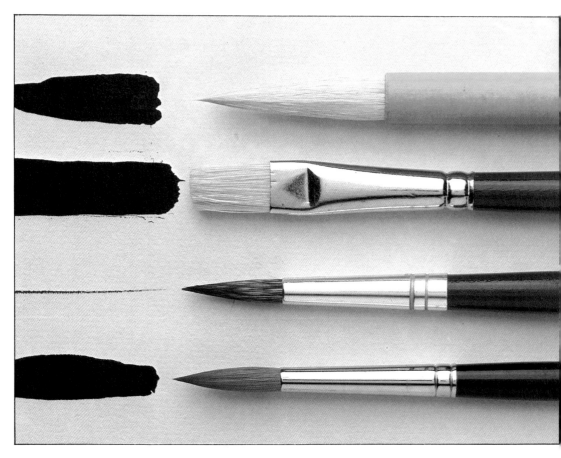

Mixing wells, palette, and bottles of ink

Right. *Mixing well, china palette, and three of the different ways in which Chinese ink is sold by one manufacturer, Pelikan. Container **A** is used mainly by the technical artist, container **B** being the most popular in general use. It is easy to dip the brush in it: Its only real disadvantage is its limited capacity—for professionals it is not economical. The best solution is to buy container **C**, which is much more economical, and to decant from it the amount of ink you need for a particular piece of work. A mixing well can be the ideal receptacle for small quantities of ink. The palette is rarely used— only for working with diluted ink.*

Paper

From left to right.
Very fine cartridge paper. This is the usual paper for ink drawing when using a brush. Rough (watercolor) paper can produce some interesting textured surfaces. Coated paper produces shiny black areas and allows for the surface to be scraped away.

Techniques

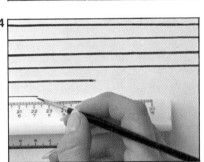

1. Fine lines, straight and parallel, drawn freehand on cartridge paper, with a No. 4 squirrel brush.

2. Thick, irregular lines on cartridge paper, obtained with the same brush but varying the pressure.

3. Freehand loops on cartridge paper with a No. 4 brush. Care must be taken to maintain the same thickness of line with each loop. Try, also, to keep an even intensity of black.

4. Fine straight lines drawn on a piece of coated paper with a No. 2 brush; the hand guides the ferrule of the brush along the edge of the ruler.

5. Cross hatched lines on cartridge or coated paper, drawn in three stages. The first series was drawn with an almost dry brush, the second with a semi dry brush and the third with a fully loaded brush.

6. Textured effect on rough paper, achieved by rubbing the surface with a lightly loaded hogs' hair brush, leaving hardly any mark, to obtain the gray shading.

7. An experiment on coated paper, consisting of scraping across a series of black lines (No. 2 brush) with a razor blade, scalpel, or craft knife.

8. The coated paper is ideal for negative work; white lines can be traced (scraped) across an area previously covered with black ink. Depending on the type of knife used, thinner or thicker lines can be created.

Line and color technique

Right. For this demonstration, Juan Sabater has chosen an architectural theme that because of its intricacy, may seem excessively complicated. However, as you will see, the technique applied will allow us to merely suggest the decorative detail. The most important objective is to represent the structure of the architectural elements and the way the light falls on them, using the limited means that we are happy to accept as part of drawing with brush and ink.

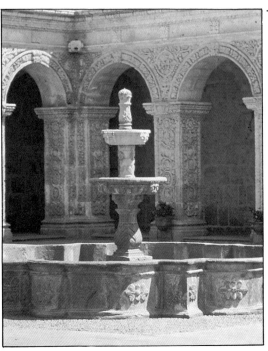

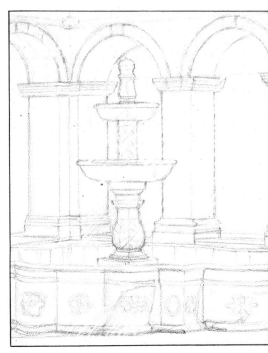

1. Outline drawing

Once the limits of the drawing have been established (notice that Sabater has left out part of the cornice), the artist has made a meticulous sketch of his subject. This must be accurate in line and perspective, because it will be very hard to alter anything later.

2. The first strokes

Following absolutely the lines of the sketch, the darkest areas have been blacked in with the brush. Notice that the moments in which the brush was drying up have been used to indicate the half-tone areas around the base of the fountain, for instance. The lines of the arches have also been drawn in with a fairly dry brush.

3. Laying the overall tone

Using the tip of the brush, Sabater has indicated tonal values that give the picture a more descriptive quality than you might expect, given the intrinsic harshness of black and white contrasts. Notice the direction of the strokes: In the columns and arches, they tend towards their respective vanishing points (this also enhances the feeling of depth), while elsewhere, vertical lines separate visually the different architectural elements.

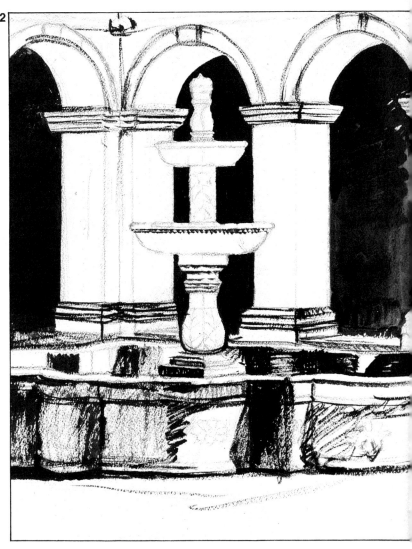

Top, right. Outline drawing of the theme, indicating areas of light and shade.

Right. The drawing after the first few strokes and areas of ink have been applied.

4. Final stage

On top of the previous stage (see the details shown above), the artist has tried to build up texture by cross hatching over strokes he has already drawn. Then, using free brush strokes, he has indicated the floral designs around the base of the fountain and finally, with even more random brush work, he has barely suggested the decorative work on the columns, walls, and arches.

As you can see, although in this case the intention was not to use the dry brush technique, there are inevitably moments in which the drier brush produces less intense strokes. It is precisely these irregularities that give this type of drawing a softness rather like that of an etching.

Left. The finished work: Juan Sabater's drawing using a brush with Chinese ink.

Dry brush technique

Some initial advice

The dry brush technique requires patience for one very simple reason: It is very difficult to know exactly what gray will result from a brush that has been allowed to dry. If, before starting on your drawing, you wish to know which tone of gray your brush will produce at any given moment, the only way to find out is to try it on the same type of paper.

You will have to do this with every new loading of the brush. Sometimes you will need to dry the brush by rubbing it on a piece of paper until you achieve the desired tone. In other words, patience is a virtue.

An example from Juan Sabater

Working from the photograph on this page, our friend Sabater has created the drawing on the next page, by means of the stages we are about to show you.

1. Outline drawing

The basic outline has been drawn with faint pencil strokes (2B) on a medium textured watercolor paper so as not to impede the application of the ink.

2. Laying the overall tone

A wide, flat ox-hair brush (No. 14) is loaded with ink and then rubbed over a piece of scrap paper; with the lightly loaded brush, a soft background tone is laid in. In the same way, with varying strengths of gray, the main areas of the drawing are indicated (except for the tree in the foreground) and the overall tones are established.

3. Detailed work and completion of the picture

Sabater has used two paintbrushes for this final stage: A round brush (No. 6) with a good point for the blackest linear work and a flat brush for the gray tones. Because it is almost impossible to make alterations with this technique (there is always the last resort of removing pigment with the razor blade, but you risk damaging the paper), the artist has carefully regulated the tone of every brush stroke used in his drawing. Only through this patient, diligent approach can the perfect balance of tones in the landscape be maintained, ranging from the intense blacks of the foreground to the subtle grays of the sky and the background hills.

1

2
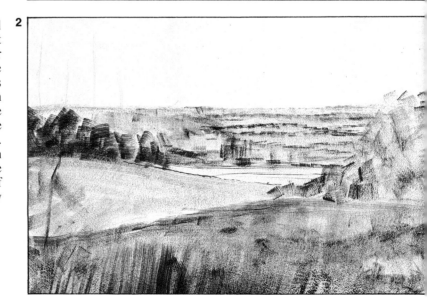

Left. Close-ups showing a well-loaded brush drawing black lines of varying thicknesses and a flat brush working on the wooded area to the right of the picture, applying a variety of tones.

Below. The completed drawing. It is a good example of what the dry brush technique has to offer.

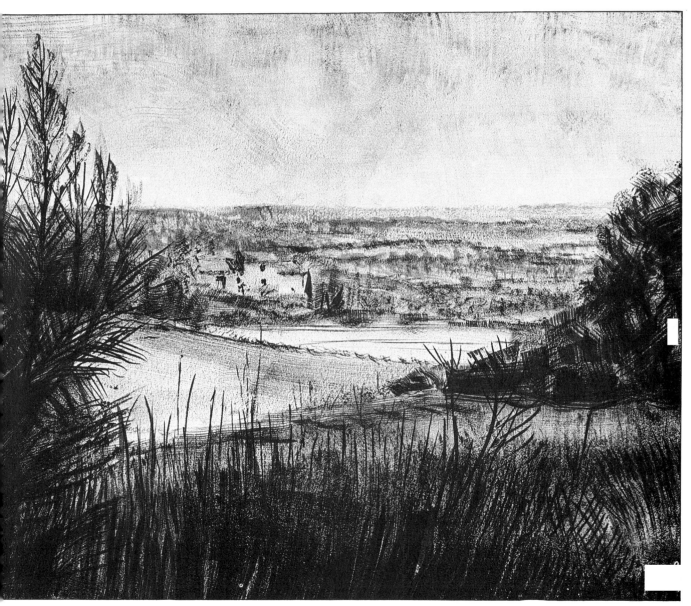

Study of the human head

The word "rule" is synonymous with a law or precept. To establish a rule for drawing the human head implies fixing the conditions that must apply for the head to be correctly drawn. Of course, certain generic norms may be established, but we should never expect them to be universally applicable. The rule relating to the proportions of the human head, for instance, provides a reliable guide for drawing imaginary faces or for setting down the first few lines of a portrait. But clearly in many cases this rule cannot be mathematically corroborated.

The currently accepted law (there have been many) dictates that the distance between the upper part of the skull (without the hair) and the lowest point of the chin is equal to three and a half times the depth of the forehead, which is regarded as the basic unit of measurement under this rule. All the proportions are calculated by means of further subdivisions. Notice (see next page) that an adult head, seen from the front, is three and a half units high and two and a half wide. The first unit comprises the depth of the forehead down to the base of the eyebrows and the second reaches to the base of the nose. It is clear that the space between the eyebrows, the nose and the mouth form the vertical axis of this scale, while the eyes are situated on the horizontal scale. Within this formula there are many facts to observe and memorize. For example:

• The depth of the ear measures one unit and its extremes coincide with the line of the eyebrows (C) and the base of the nose (E).
• The distance separating the eyebrows from the center of the eyes (C-D) is ¼ of a unit.
• Halving the distance E-G (one unit) gives us a line F that coincides with the bottom of the lower lip.

Although it is true that the average head will not conform to these rules in every respect, it is interesting to note that certain proportions are nearly always applicable.

For example: The distance between the two eyes is almost always that of another eye and, almost invariably, the first three vertical units, consisting of the distance between the nose and the chin, the nose itself, and the forehead, are equal.

The nose and the ear also tend to be of equal proportions.

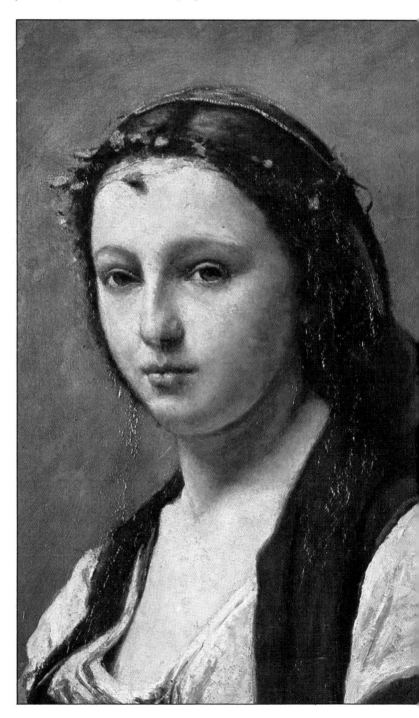

"Young woman with a pearl ring" by Jean-Baptiste Camille Corot. *Oil on canvas (21 ¼ × 27 ½ in.(54 × 70 cm) The Louvre Museum is home to this magnificent portrait (somewhat rem-* iniscent of the Mona Lisa) in which, apart from a wonderful mobility of technique, we can also observe the almost total application of the rule we have been studying.

The rule of proportions

 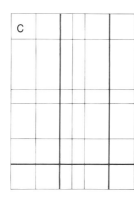

Left. *Diagrams defining the proportions of the human head.*
A. *Scale showing the height and width of the head, based on a unit of measurement.*
B. *The vertical and horizontal axes seen from the front.*
C. *Guidelines for the outer extremes of the nose and the eyes and line showing the level of the lower lip.*

Below. *Showing the depth of the different elements of the face:*
A. *Upper extent of the skull.*
B. *The hair-line.*
C. *The line of the eyebrows.*
D. *The level of the eyes.*
E. *The base of the nose.*
F. *Base of the lower lip.*
G. *Lower extent of the chin.*

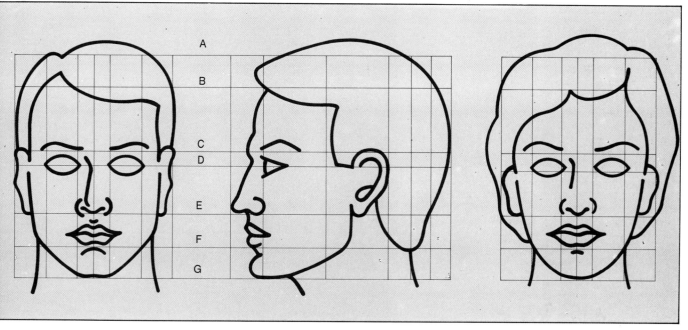

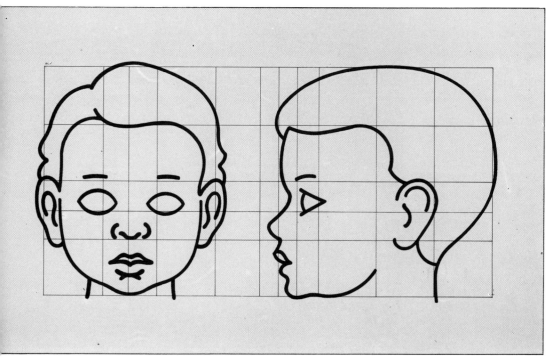

Left. *Rule relating to the head of a child (two to five years), is quite different from that of an adult. The most obvious difference is that the eyebrows, rather than the eyes, mark the half-way point in the depth of the head. The distance between the eyes is greater than in the adult. The forehead is broader and there is generally less hair at the top and sides. The nose is turned up and the ears are bigger, the chin rounder, and so on.*

The skull

The framework of our body is the skeleton and our physical characteristics depend, primarily on the shape of our bones. This is particularly obvious with the shape of the head. The skull is a bony structure with a very slight surrounding musculature. With the head, you can really "see the bones," something that does not happen elsewhere in the body where the skeleton supports a heavier layer of muscle. Because of this, without trying to memorize every bone, it is worth it for the artist to have a clear idea of the structure of the human skull, which constitutes the basic structure of the head of each individual. For the artist, the formation of the skull should provide the basic structure for any drawing of the head.

An analysis of the skull leads us to conclude that the head is made up of a sphere that encompasses the skull area and a more or less triangular appendage comprising the two jawbones. This singularity can be clearly seen in a profile view of the head. Seen from the front the sphere looks flattened on both sides, indicating the areas that, in the living person, are occupied by ears.

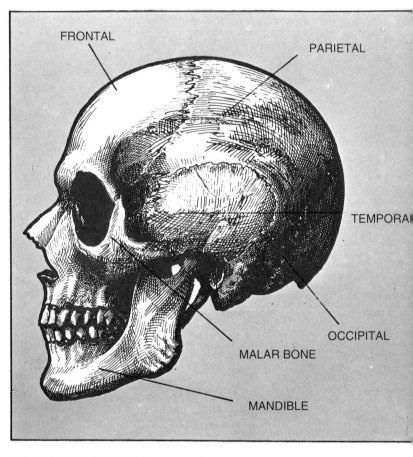

FRONTAL
PARIETAL
TEMPORAL
OCCIPITAL
MALAR BONE
MANDIBLE

Below. *In the form of the skull we have a good base for an outline drawing of the head. These diagrams illustrate the details described above. Observe how the three* *units of the rule of proportions relate to the shape of the skull. It is important to know how to reduce the skull in your mind to a sphere-shape to draw a head in any position.*

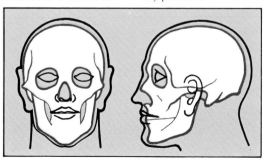

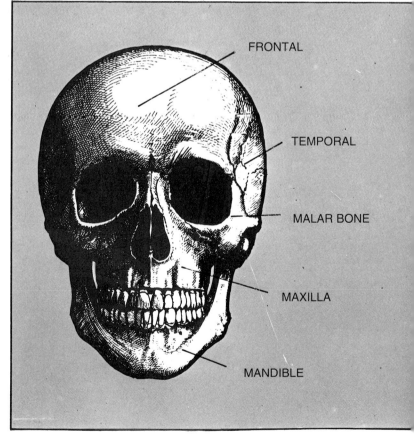

FRONTAL
TEMPORAL
MALAR BONE
MAXILLA
MANDIBLE

Construction of the head, based on a sphere

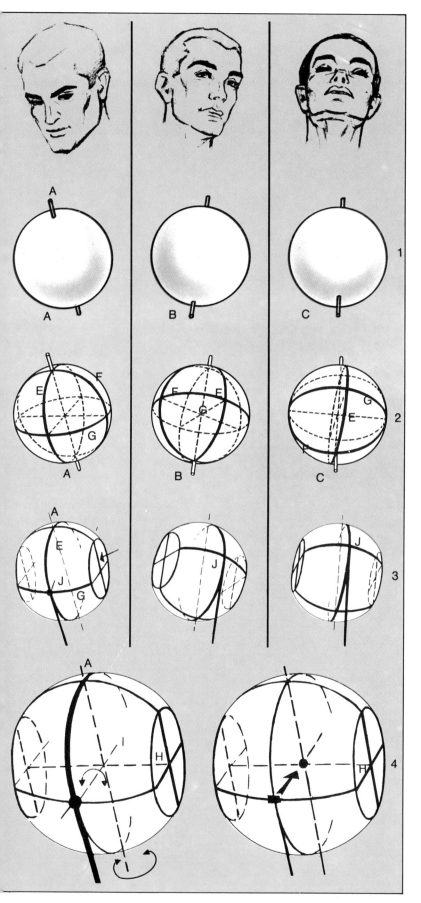

Although this explanation is valid for any position of the head, we will refer to the three most frequently described positions: Looking down at an angle, up at an angle, and directly upwards (seen from the front).

1. First, we have to imagine that the sphere of the skull has an axis running through it.

This axis, which would coincide more or less with the line of the neck, is enough to give us an idea of the position adopted by the head we are about to draw. Sphere **A** corresponds with a head looking downwards at an angle; **B** corresponds with a head looking upwards at an angle; and **C** shows a head looking upwards, seen from directly in front.

2. Now we will describe three perpendicular circles (in perspective) around our sphere (which we will imagine to be transparent) in such a way as to determine the meridian **E** that symmetrically divides the face; the equator **G** that corresponds to the line of the eyebrows; and another meridian **F** that divides the skull into a front (face) half and a rear, or occipital, half. As you can see, it is vital to bear in mind the perspective of the circle and the sphere. Look at the three circles **E**, **G**, and **F** seen in relation to the perspective of positions **A**, **B**, and **C** of the head.

3. Remember that, in reality, the sphere of the skull doesn't exist. The ear areas are, themselves, individual circular planes. We have pointed out the diameters of these circles with an arrow. From point **J**, at the intersection of circles **E** and **G**, we have drawn a line straight downwards, parallel to the axis **A** of the sphere. This straight line is clearly the axis dividing the face symmetrically, seen in perspective.

4. Look at the various axes: Axis **A**, for right to left movement; axis **H**, for up and down movement; and axis **I** for lateral movement, or tilting the head sideways from right to left. These axes are a guide when constructing a drawing but, as you will have guessed, do not correspond to the anatomical movements of the head that, in life, are dependent upon the "atlas" and "axis" vertebrae at the base of the occipital bone.

Let's continue with the construction of the head. Obviously, our next stage consists of marking out the three main units across the axis that divides the facial features.

5. The lower jaw is put in place. We have envisaged it as a kind of horseshoe revolving around two pivots situated a little below axis **H**. Anatomically speaking, these pivots would be the "masseters," or muscles controlling the movements of the lower jaw. Notice that the width of the chin, equal to the distance between the eyes, is a fifth of the overall width of the head. In our diagram we have indicated it with a bolder line.

6. Next, the level of the mouth is established. The lower lip, as we know, is located at the middle point of the third unit, between the chin and the base of the nose. If we were to pass another circle in perspective through this point, we could also determine the maximum width of the lower jaw, at points **O**.

7. The construction of the jaw can be completed with just a few more strokes. Two straight lines are drawn, down through the pivots at point **O** on each side and then two sloping lines, defining the lateral limits. By now you might be asking yourself if it is really necessary to go through this entire process every time you draw a human head. The answer to this is, "It depends." It depends on the skill and experience of each artist and, above all, on the type of work being produced. With a portrait, it is quite possible that these principles will not be considered, or perhaps only superficially considered. However, when drawing an imaginary head (or drawing from memory), the rules become more important. Indeed, in certain situations where the attitude of the head requires us to depict a pronounced foreshortening effect, they may well prove indispensable.

Left. We have repeated two drawings, the first set of three in this section, so that you can compare the vertical and horizontal lines defining the units of measurement with the circles corresponding to the perspective drawing.

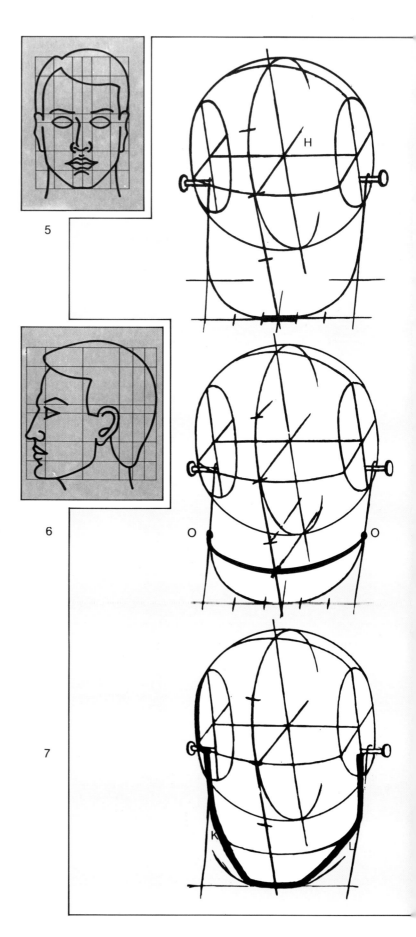

5

6

7

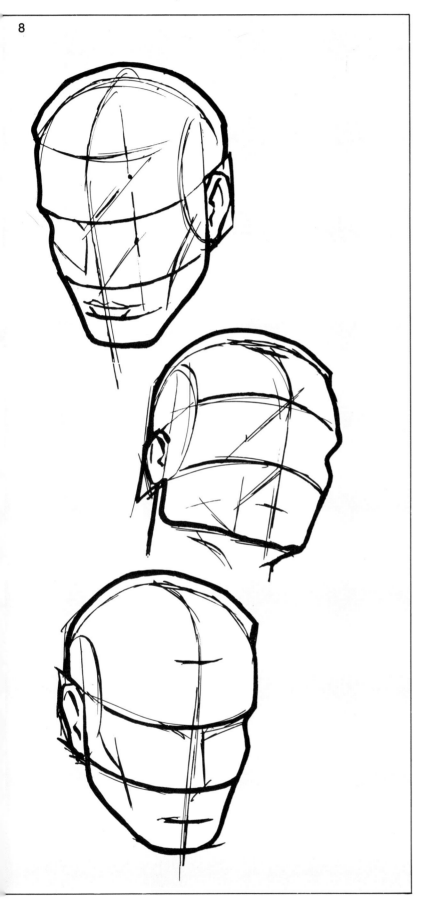

8. Without completely losing the circles that correspond to the divisions of each unit, or the one we have used to locate the mouth, we can begin to outline the more definitive features. For instance, we can sketch in the ear, trace the line of the mouth more precisely, define the angle of the hollow of the eyes between the curves of the brow and the cheekbone, and so on. We can also indicate the thickness of the hair.

Finally, we have all the features of the head drawn in proportion as indicated by the rules. The construction lines have defined the location of the different parts of the face, which we can now begin to draw in properly. Notice that, in the first and third diagrams illustrating section 8, the lines of the mouth and the profile of the nose have been suggested.

When drawing the eyebrows (on the line cutting the sphere in half), remember that they do not form part of a perfect circumference, but, in fact, consist of a slightly inward sloping straight line and a much shorter curve, sloping slightly downwards. This can be seen in the illustrations on previous and later pages.

We know that the eyes are situated at a third of a unit below the line of the eyebrows. We should also pay careful attention to their position in relation to the ears and the nose, whatever the angle of the head.

We recommend that you not start drawing "finished" human heads until you have produced a number of outline sketches like those on the left. For the time being, don't worry about finishing. The important thing is to produce sketches in which the circles of the eyebrows, the nose, and the mouth are perfectly situated. Details can wait until later.

■ Applying the rules

When situating the eyes, the nose and the mouth, the problem of foreshortening may arise. For instance, when the head is bent forwards, the eyeball is "hidden" beneath the eyebrow, and we can no longer gauge the distance between the eyebrows and the eyelids. Conversely, when the head is directed upwards, the orbital area seems to expand, so that the eyes are further away from the eyebrows. This apparent distortion caused by perspective is shown graphically in the adjoining illustration. However, the unit divisions on the traditional scale of proportions correspond to the same divisions seen in perspective.

To conclude this section on the rules of proportion of the head, and also as a preparatory exercise for future studies based on the human figure, try to draw a head following these instructions:

1. On an ordinary piece of drawing paper, using a 3B pencil, make a freehand sketch of the sphere of the skull, with a diameter of approximately 6 in. (15 cm). Indicate the angle of the cranial axis (A).

2. Indicate the planes of the ears and draw the circle corresponding to the level of the eyebrows. From the center of the sphere, marked K, establish the point K', and through this point draw the axis dividing the face into symmetrical halves (the line running between the eyebrows).

3. On this axis, mark the levels corresponding to the base of the nose, the chin, and the mouth (lower lip).

Begin to erase the construction lines as you build up the distinct elements of the face.

4. Making any necessary adjustments along the way, prepare your drawing for the first areas of shading. On this occasion, we suggest that you go no further than a simple indication of the principal areas of light and shade.

Follow our instructions to the letter and you will discover that—using these rules as a starting-point, and the infinite number of perspective versions (one for every conceivable position)— drawing the shape of a head is not as difficult as it might seem. Try to achieve a result similar to the one in this illustration, onto which, for the sake of clarity, we have superimposed the principal construction lines in red.

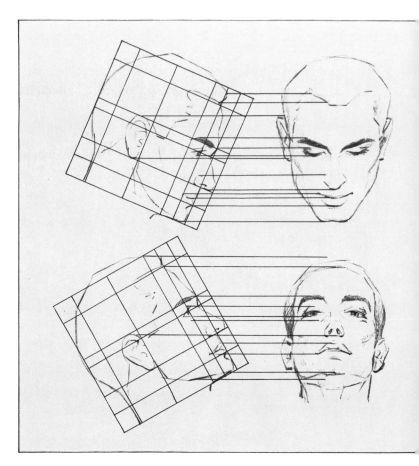

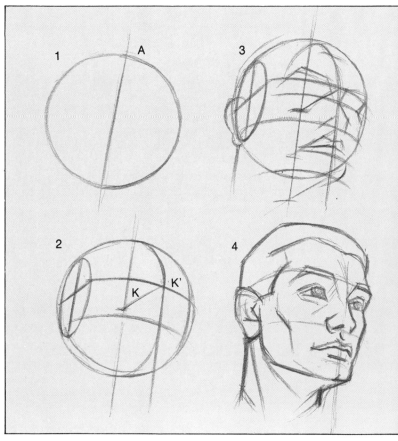

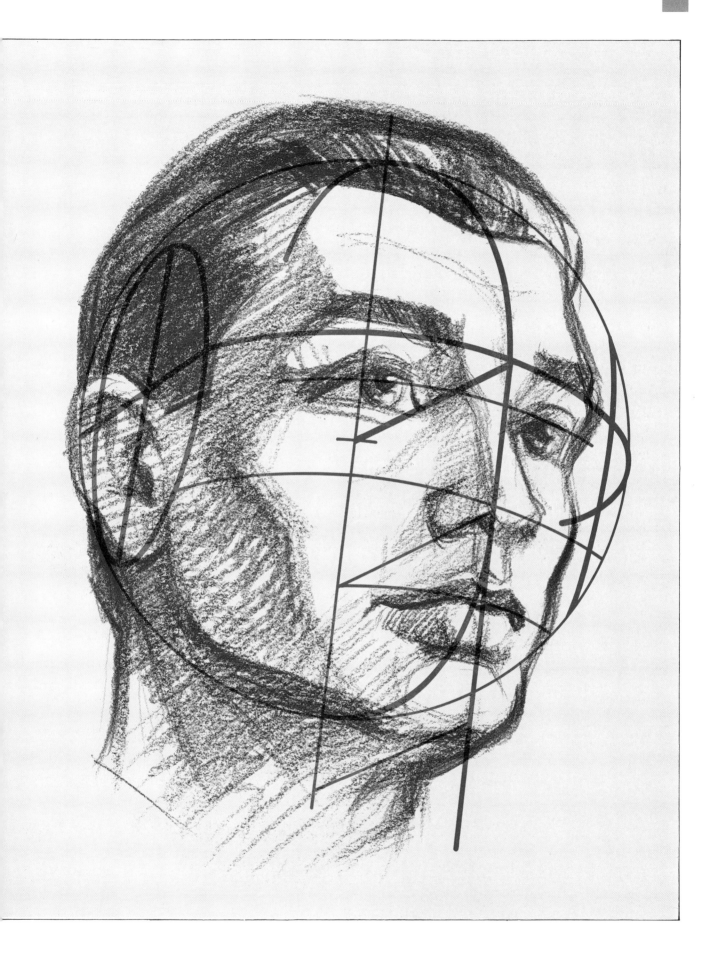

The features

An understanding of the rule of proportions we just studied helps us to draw the human head (real or imaginary) with all the elements correctly situated: Eyebrows, eyes, nose, and ears in particular. Our new objective is to explore the form of these facial elements and to learn how to draw them.

Strangely enough, the parts of our fellow creatures seen most often, and of ourselves as we look into the mirror each day, are the parts we notice the least. Rarely do we stop and study the shape of the nose or eyes or eyebrows of those we live with. And if we cannot picture them in our own minds, how can we begin to describe them on paper?

The study we are about to undertake uses archetypal features as its points of reference, as well as generalized examples and observations. However, we recommend that you try to apply these lessons to your own features. Sit in front of a mirror and look carefully at yourself: First directly, then with the head a little to one side, then looking slightly up or downwards. Try and discover how your own features are a modification of the standard forms we are going to demonstrate.

We think it is fair to say that the task of the portrait artist is, fundamentally, this: To demonstrate his understanding of the formal elements of the human face through the specific features of his own models.

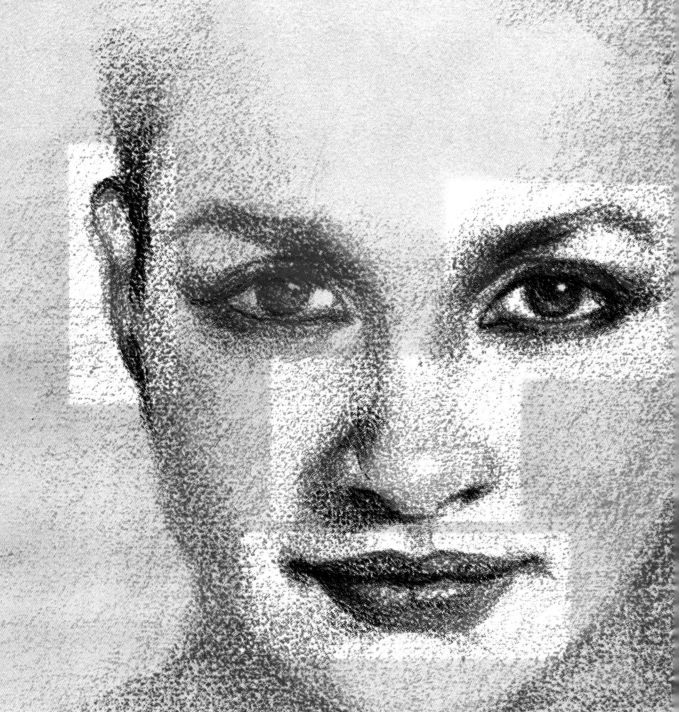

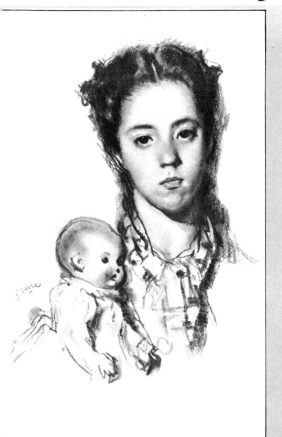

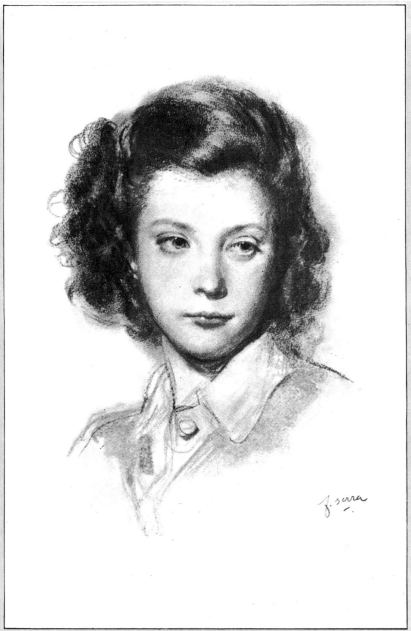

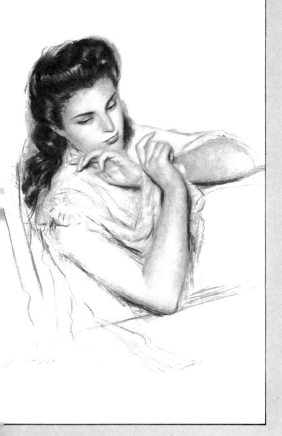

Left. *Pencil portrait by Alfred Opisso. Even in this angled pose, the rules of proportion have been observed. It would be an interesting exercise to demonstrate this by tracing this face and comparing it with our study based on the rules of proportion.*

Above. *Two pencil portraits by Francesc Serra. Serra's mastery of this genre is indisputable. What we wish to point out is that two such apparently different faces display almost identical proportions. It is not the proportions that distinguish them, but rather the individual features: The eyes, nose, mouth...*

◼ The eyes

The form of the eyes is spherical

This is the first important observation: The eyes are in the shape of a sphere and, to be more precise, a sphere with a little spherical cap that corresponds to the lens.

We can imagine this sphere with its little cap seen from in front (1a), in semi profile (1b), in profile (1c), or looking down at an angle (1d); from these diagrams you can see the basis for drawing the visible part of the eyeball and the shape of the eyelids.

Imagine (2) that this sphere is covered with an elastic substance $1/3$ in. thick and that we make a small, transverse cut just above the cap. If we open this cut like a buttonhole, we will have a shape similar to that of the eyelids, of which (and this is important) we will always see one of the edges. Springing from the outside of these edges are the eyelashes. Taking the pupil of the eye as an approximate center, each eyelash follows a radial direction from the center of the lens. Look at diagram 3, a,b, and c. Now we can see the external form of the eye region. Containing it on the upper side are the eyebrows, straight and slanting slightly upwards at first, then arching downwards at the outer edges. Immediately below the eyebrow is the upper eyelid. When the skin is taut, the eyelid follows the spherical shape of the eyeball, a shape lost beneath the fold of skin when the eyebrow is lowered (4b and 4c). It is worth noting that the eye opens and closes almost exclusively through movement of the upper eyelid. The lower one hardly does a thing. This observation should remind you that, when the eye is open, the curve of the upper lid is much more accentuated than that of the lower lid, which is more like a horizontal line passing through the lachrymal duct. In other words, the "almond" of the eye is not horizontally symmetrical. Notice this in diagram 5a and don't forget it when you come to draw the outline of the human eye.

Another thing to remember is that the eyelids open over a curved surface, so that you will almost always be able to see the thick edge of one of them. Also, the eye is never symmetrical. Look at diagrams 6a and 6b. Finally, bear in mind the "radial trajectory" of the eyelashes so you will be able to draw them from any angle.

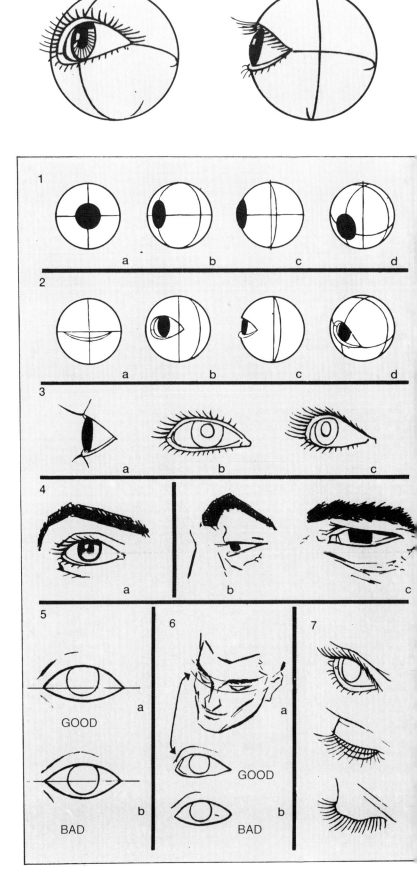

Moving on from this diagrammatic approach, we will now consider the tonal values of the region around the eye. We will assume that our drawings are clear enough to save us too much detailed explanation. Among artists, pictures paint a thousand words.

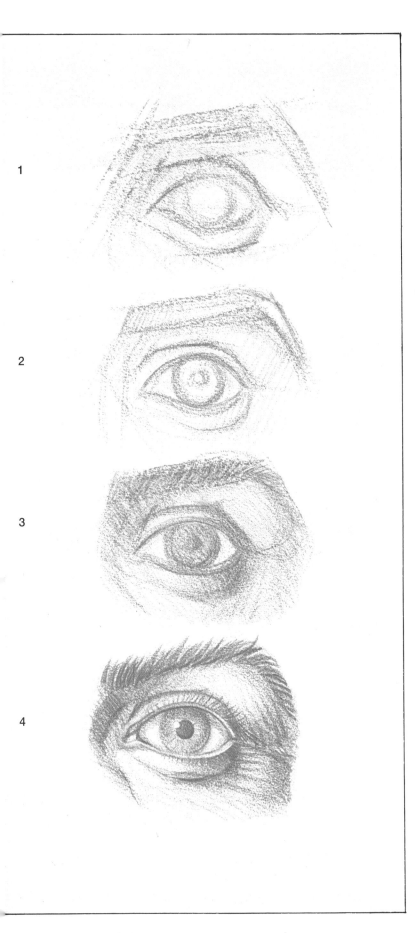

1. The soft pencil lines have situated the eyebrow that encloses the top of the eye cavity, providing a good guide to the structure and location of the eye. These faint strokes will be strengthened later.

2. Continue the logical building up of outlines. This is the time to adjust the initial sketch and to prepare the drawing for the addition of light and shade. Notice that the line of the lower lid, which curved downwards too much in the first drawing has been altered.

3. The pencil has begun to describe depth, darkening the folds of the eyelids and emphasizing the curve through gradated shading on the right half. The left part of the hollow *of the eye has been darkened, with the lachrymal duct at its deepest point. The iris and other details have also been more clearly defined.*

4. Notice that the final stage has consisted mostly of completing the work begun in the previous phase. However, it is worth noting the following points:

•There is a shadow, on the eye itself, projected by the upper eyelid and the eyelashes.
•The spherical shape is conveyed by the shading in the white of the eye.
•The thickness of the eyelids can be seen clearly.
•The "twinkle" in the eye, expressed through a spot of white on the edge of the pupil, is very important.

Naturally, the tone and shading of the eyes depends on the lighting. Different lighting produces different effects but, in every case, the lines and curves to be drawn will be similar. For instance, imagine this same eye, lit strongly from the right hand side. The light and dark areas would be reversed, wouldn't they? Why not try to draw it yourself?

The direction of the gaze

Up until now we have been analyzing the form of the eye. But there are two eyes and we usually have to draw them both. If you already find drawing one eye difficult, then having to draw two will only add to the problem. Why is this? Firstly because the face is constructed on a curved surface and the eyes, which are spherical, are "embedded" in individual hollows on this surface. Because of this, we will only see both eyes in the same way when seeing the face from directly in front. In every other case (in the majority of cases), one eye will be seen more in profile. This fact becomes obvious in sketches 1 and 4 in the series of illustrations shown here.

In sketches 2, 3, and 5 we have tried to show another problem: The fact that the eyes we draw really "look" and have their own expression. In this situation, the direction of the gaze is very important, conveyed partly by the openness of the eyelids and also by the "attitude" of the eyebrows.

The eyes, the eyebrows, and the mouth are the main factors in the expression of the face.

As well as expression, the gaze indicates direction and, when drawing a face, we must be careful to show both eyes looking the same way; otherwise we will end up with squinting or a cross eyed look.

The eyes look up or down simultaneously, as if they revolved around a single axis (see the diagram below) and when looking to the right or left they move as if controlled by a mechanism similar to that which drives a car.

In truth, these problems have just one solution: Careful observation of the model to try to understand what his or her eyes are "saying," when drawing from life and, when working from the imagination, trying to imagine mobile spheres operating inside their hollows and half covered by the eyelids.

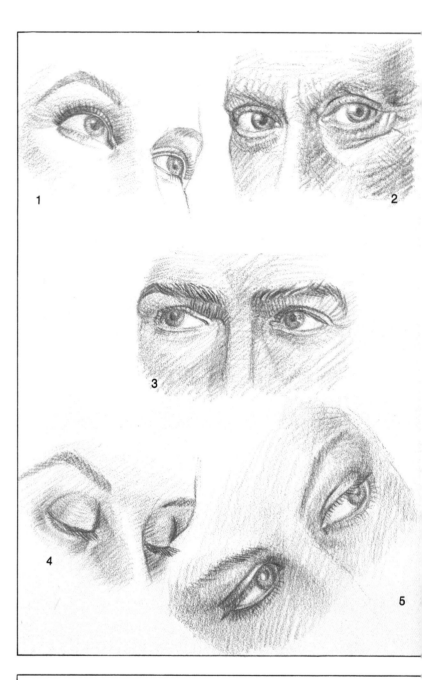

The eyes move up or down together, as if they were both fixed to a horizontal axis.

The ears, the nose, and the lips

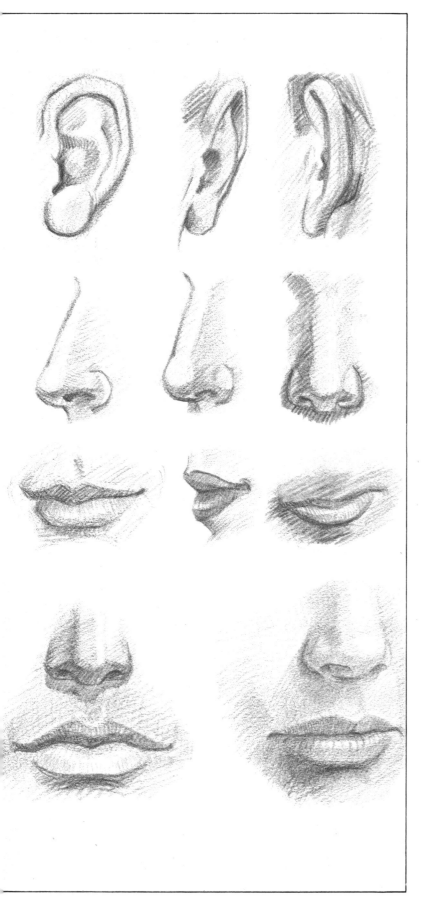

However young you are, you will have seen countless noses in your life. However, would you be able to give an accurate description of the shape of a nose? Or an ear or a mouth, for that matter? The fact is, we often hardly notice what we have in front of us every day. You might say we look without seeing.

This is a luxury the artist cannot afford. The artist must look, not only at a nose, a mouth or an ear, but at the precise shape of that nose, that particular mouth or ear. The drawings on this page can be a good starting-point for getting to know these forms. They may be taken as prototypes you should copy until you can reproduce them from memory, using them as a base from which to analyze the characteristics of other, specific models. We have not attempted to go into details of form. Sometimes there is a tendency in drawings to exaggerate descriptive details that are often more subtle, especially in a woman's face.

Move on from these prototypes, and try to make some studies from life. Draw your own nose or mouth, from directly in front or at an angle. Ask your family to pose for you so you can practice drawing these elements so vital to the art of portraiture.

Study the shape of the lips, the hollows at the corners of the mouth where an upwards or downwards curve shows so much about the mood of a person. Explore the difference in tone between the upper and lower lips, caused by the fact that one of them (usually the lower) is in more direct light. Notice also that, generally speaking, a woman's lips are darker than a man's; they are shinier and also show more clearly the little furrows, characteristic of the skin on the lips. We stress again that you should copy these drawings over and over again, until they are engraved forever on your brain.

Practice using different media: Lead pencil, sanguine crayon, charcoal, and so on.

Pencil drawing of a female face

With the detailed study of the proportions of the human head and the following analysis of the features (eye, nose, mouth, and ears) still fresh in your memory, we think it is time you start to explore the art of portraiture. We recommend that you work from photographs in the beginning so you become familiar with different features and expressions. It is a good way to gain experience before working with a living model. Exercises like the one we have illustrated on these pages can be broken down into three phases, each one bringing its fair share of trial and error, alterations and irritations, all of which are part and parcel of the creative process.

1. As always, the pencil describes the first lines of your drawing, guided by intelligence and not by magic: The line of symmetry, the line of the eyes, of the mouth, and so on, all in accordance with the rules of proportion. Then the oval of the face and the situation of the features can be adjusted to the characteristics of your model.

2. Between the previous stage and the end of this second phase, there is a lot of work to be done. The features continue to be built up by means of new, tentative strokes, further observation, and comparison between the drawing and the model; the initial tone is laid down, which helps to define the contours of the face. At the end of this stage there should be a definite, visible likeness. However, anyone who cannot see the original photograph of our model may be wondering if it is a man or a woman.

3. Here we have the finished drawing. There is no longer any doubt that the model is a woman. How have we gone from phase 2 to a real portrait of a particular person? We had already defined the features in the previous stage but the change is largely due to the effective use of light and shade to soften areas that were previously quite harsh, and to describe form more precisely and decisively: The eyebrows, the folds of the eyelids, the lines around the eyes, the lips, and so on.

1

2

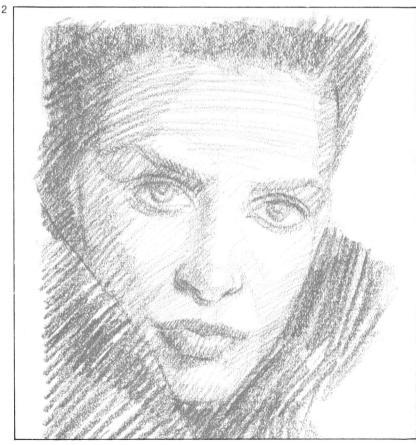

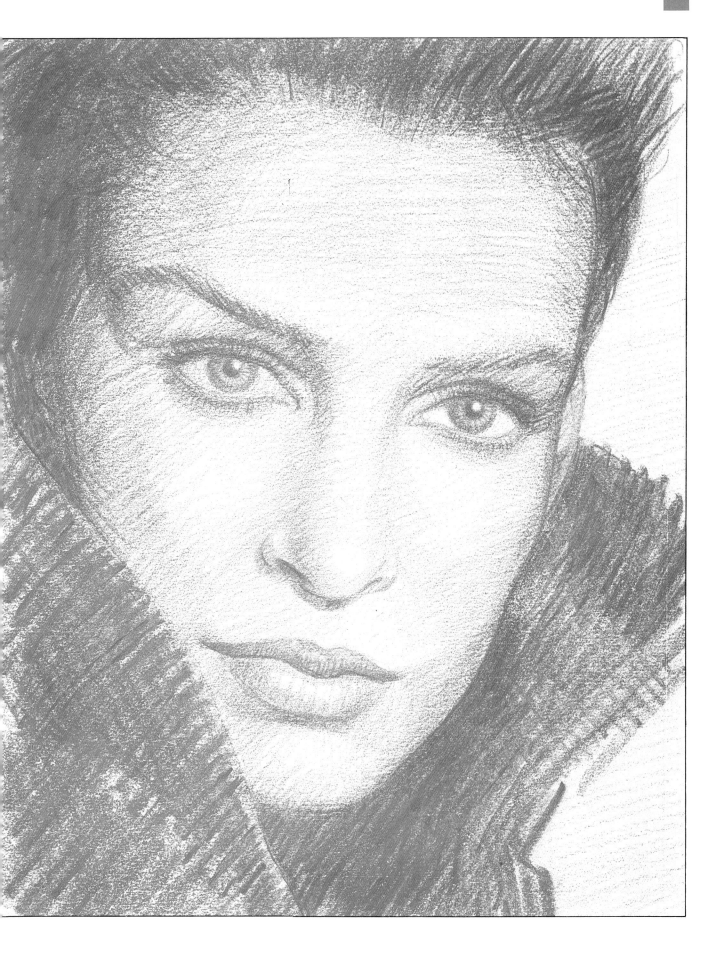

The human figure

Great artists have been preoccupied with the expression of Beauty and, when attempting to convey it through the medium of the human body, have turned their attention to formulating a law of proportions: that is, a series of mathematical relationships that, based on one simple proportion, determines all the other measurements of the ideal human form.

The two best-known and most widely accepted formulae are a legacy of the influence of greco-roman culture and were provided by two ancient Greek artists. These are known as the law of Polycletus (5th Century BC) and the law of Lysippus (4th Century BC).

The most representative of Polycletus' work is the statue known as "The Doryphoros." In this sculpture, all the measurements of the body conform to certain simple mathematic relationships, based on a single precept: *the total height of the body is equal to seven and a half times that of the head.*

The law of Lysippus defines a slightly more slender version of the human body as the ideal form. His initial precept is that *the total height of the body is equal to eight times that of the head.*

Once a rule of proportions goes beyond that of eight heads as equaling the total height of the human body, we enter the realm of heroes and demigods rather than ordinary men and women. Such is the case of the famous Apollo Belvedere, attributed to Leocares, a statue that follows the rule that the body measures the height of eight and a half heads. In any case, knowing and applying a law will help you to respect proportions in your drawing. Finally, bear in mind that in our sketches we have confined ourselves to looking at the most significant proportions relating to the levels and heights of certain parts of the body without going into so many details as to inhibit your spontaneous creativity.

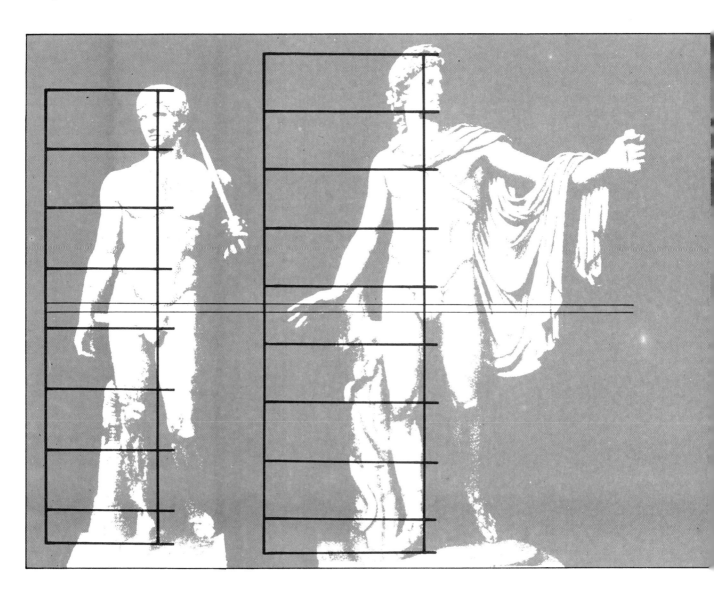

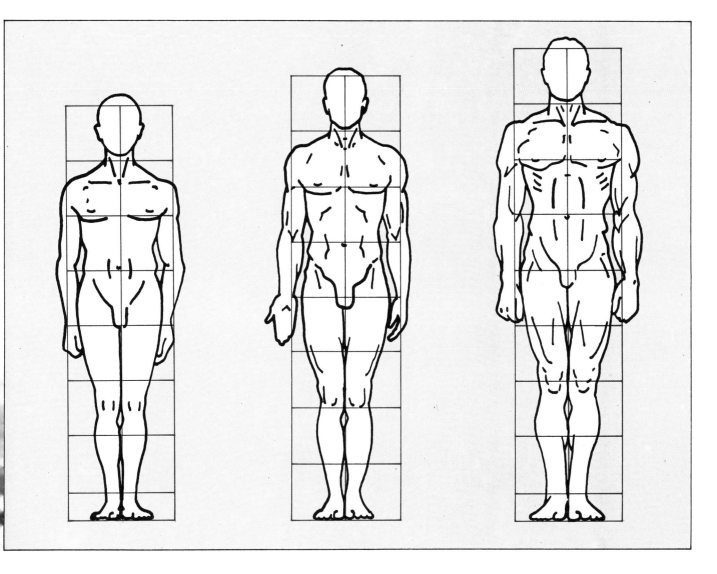

Of course, the classical laws leave no loose ends: Every measurement you care to consider within the human body has its own relationship with the unit of proportion—that is, with the height of the head.

From left to right, you can see diagrams representing three male bodies that base themselves, respectively, on the law of seven and a half heads, eight heads and eight and a half heads. Look at the differences of form and structure resulting from the adoption of one or other of these laws.

These days, it is safe to say that the average man obeys the law of Polycletus (seven and a half heads), although in the last few generations there has been a tendency towards the ideal human form described by Lysippus in the 4th Century. The human race does seem to be evolving towards a more slender form.

As artists, we can obviously choose whichever law best suits the physical type of a particular model but, in general, when the physical type is not immediately evident, the law most appropriate to the aesthetic considerations of the times we live in is that of eight heads to the body: It produces elegant, slender figures, without falling into the exaggeration of the Apollo Belvedere (unless, of course, we are trying to create the image of a superman). For now, it is worth noting that the fundamental differences between the three laws begin at the fourth division: The legs (from the groin area) of the first figure measure three and a half units, those of the second figure, four units, and the legs of the third measure four and a half.

Above. Diagram showing the three versions of the law of proportions to which we have referred, based on seven and a half, eight, and eight and a half heads. The most widely used formula is that of Lysippus (eight heads), with eight and a half reserved for the representation of heroic figures.

Law of proportion based on "eight heads"

We are now going to look a little more closely at the laws of proportion of the human figure. We have included the laws relating to both men and women on the same page so we can compare them.

General view. The front and rear view of the human body can be situated inside a rectangle of the following proportions:
Base: measuring two "head heights."
Height: Eight "head heights." The rectangle is divided vertically by an axis of symmetry and horizontally by seven lines producing eight equal units of one "head height."

In the male figure:
• The shoulders are situated at one third of a unit below the first horizontal unit.
• The nipples are located on the lower line of the second unit.
• The distance between the nipples is equal to one unit.
• The navel appears just below the lower line of the third unit.
• The elbows and the bend of the waist are situated on the lower line of the third unit.
• The pubic bone coincides with the exact center of the body, or on the lower line of the fourth unit.
• The knees are situated a little above the bottom of the sixth unit.
• The fold of the glutaeus muscles (the buttocks) is located approximately a third of a unit down from the horizontal line that is level with the pubic bone.
• Seen in profile, the calf muscle touches the vertical that passes through the shoulder blade.
In the female figure, although people often believe the contrary, the proportions are not very different. The structural differences between the two sexes can be summed up in these details:
• In general, the female body is shorter than the male, by about 4 in.
• Women's shoulders are narrower.
• The breasts are situated somewhat below the bottom of the second unit.
• The navel is a bit lower than in the male body.
• The waist is narrower.
• The hips, on the other hand, are wider.
• In profile, the buttocks go beyond the vertical that passes through the shoulder blade and the calf muscle.

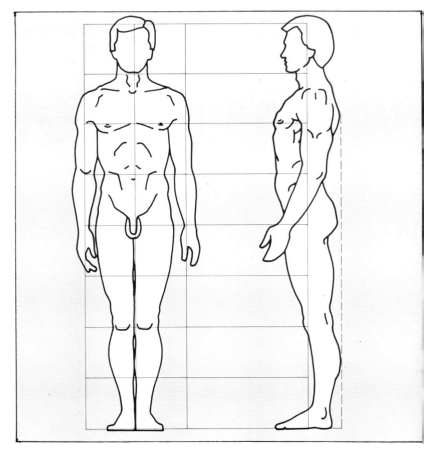

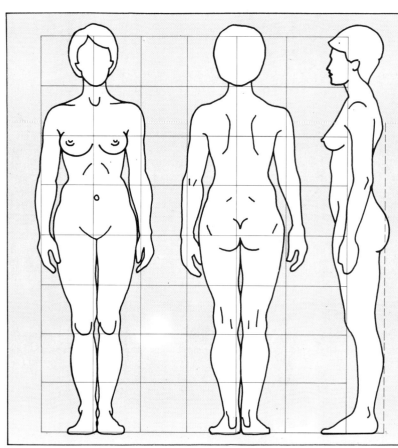

Law of proportion for children and adolescents

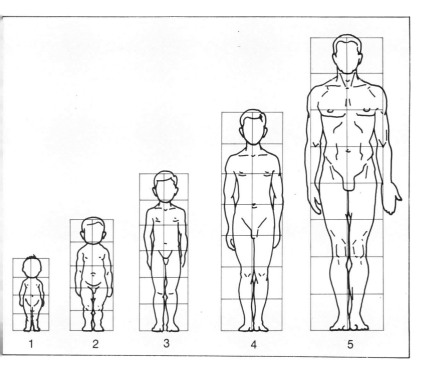

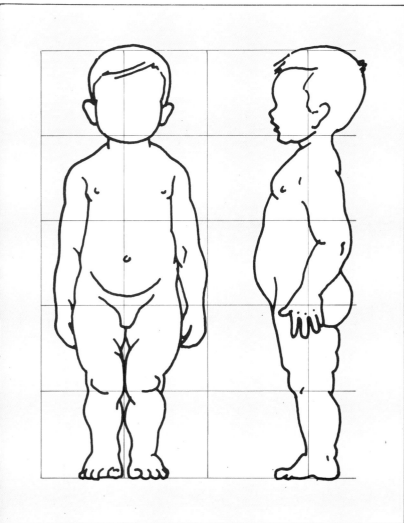

When a beginner tries to draw a child or an adolescent, there is a tendency to draw a "little adult." This is because the proportions of the human body most familiar to us are those of an adult. The proportions of the body of a child or an adolescent are more elusive; they correspond to various stages of development and we do not pay much attention to them. This should not be the case.

Our first observation should be that the head is the part of the human body that grows the least. We are born big headed, pot bellied and short legged. A quarter of a baby's height is made up of the head; its chest and belly make up almost two more quarters, so that the arms and legs appear very short by comparison. On the left (1), is a diagram representing the approximate proportions of a human being of eight to twelve months old.

In height, the most significant development occurs with the extremities. Between eighteen months and two years (diagram 2), the scale of units increases from four to five, with the legs already occupying two of them, as do the arms alongside the elongated chest and abdomen.

We know that not all children grow at the same rate but, on average, between two and six years of age, their bodies develop enough (always taking the head as one unit) to be defined in a scale comprising six units (3). The lower part of the body, as you can see, is the main area of growth.

The well-formed adolescent body conforms to a scale of seven "heads." Thoracic development and the growth of the extremities (the legs already occupy three complete units) have almost reached adult proportions. In reality, many adults never grow beyond seven head heights. It could be said that between puberty and maturity, the major development takes place in the legs, which grow from three to four units. In terms of proportion, the real difference between the adolescent and the adult lies in the relative length of the legs. Because the greatest difficulties seem to arise when drawing very small children, we have reproduced an enlarged version of our second diagram for you, as it is one of the most frequently used in the entire history of art: Consider sculptor Luca della Robbia's "children" (15th Century) or Murillo's little angels (17th Century), for example.

Elements of anatomy

In order to draw "something," it is necessary to know what this "something" is like. Elementary, you may think. However, beginners to drawing are often unaware of this fact. Even with subjects as complex as the human figure, they tend to rely on intuition without carrying out a preliminary analysis of form, even though all great artists agree that real mastery of the human form is achieved only through study of the anatomy of the male and female body.

From the Renaissance on, artistic anatomy has been considered an essential discipline in the preparation of the artist. We advise you to look carefully into this subject which, for obvious reasons, we can only touch upon in these pages; naturally, we cannot turn our course into a treatise on artistic anatomy.

There are some very good books available that can help you to understand the human form, to know the whys and wherefores of the contours of the body; unless we have this knowledge, when drawing from life, we end up reproducing what we see, without knowing why it is there.

Understanding the inner reason for the forms of the human body is the only way to interpret them correctly. Since this knowledge begins with the study of our bone and muscle structure, we will confine ourselves to offering you a summary of the main bones and muscles (the most superficial layer) that make up the human body, in the hope that this overall view will

inspire you to carry out a more detailed study of artistic anatomy.

Each artist, within his own limitations, should follow the example of Leonardo da Vinci the great pioneer of the systematic study of human anatomy as applied to art.

Lower left. Studies in anatomy by Leonardo da Vinci. They are surprisingly clear and precise.

Lower right. Anatomical study of human muscles, by the Florentine artist Alesandro Vallari.

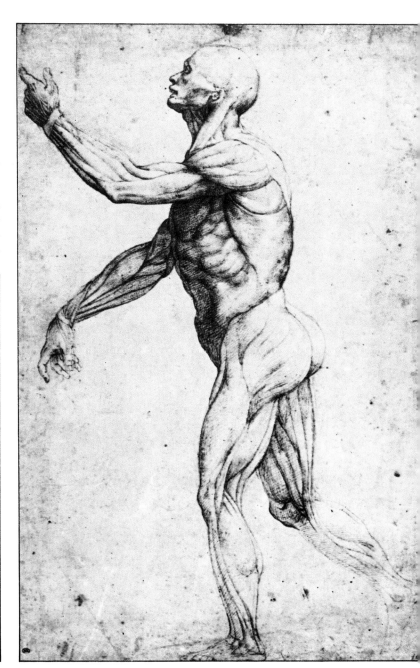

The skeleton

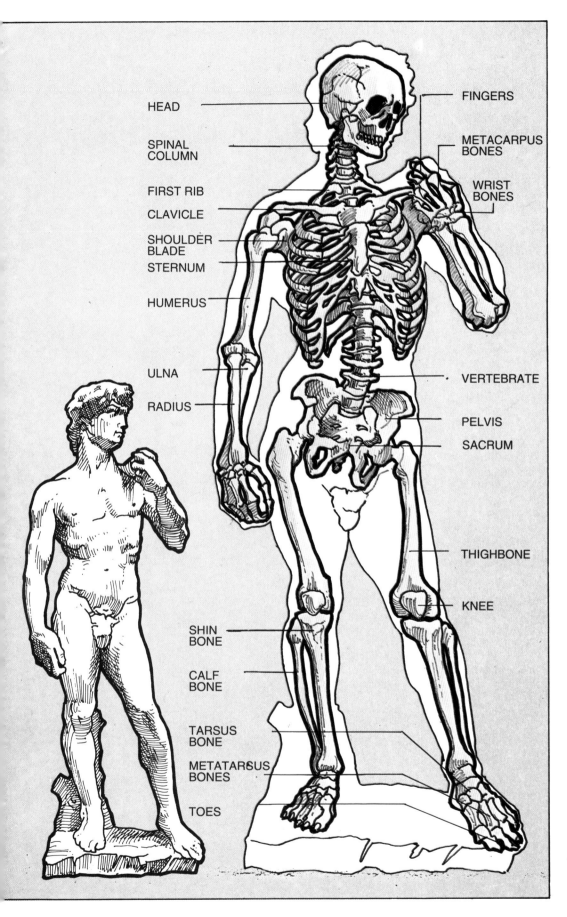

HEAD

SPINAL COLUMN

FIRST RIB

CLAVICLE

SHOULDER BLADE

STERNUM

HUMERUS

ULNA

RADIUS

FINGERS

METACARPUS BONES

WRIST BONES

VERTEBRATE

PELVIS

SACRUM

THIGHBONE

KNEE

SHIN BONE

CALF BONE

TARSUS BONE

METATARSUS BONES

TOES

The skeleton is the solid, articulated framework that supports the soft parts of the body (the muscles and internal organs) and that, thanks to the rigidity of the bones, maintains a stable structure. The skeleton could also be considered as a "collection of levers," driven by the muscles, that both facilitate and restrain the movements of the body. The joints are the focal point of interest when describing a particular pose and play a large role in the representation of foreshortening. This is evident in Michelangelo's "David," the famous statue we have described in a pen drawing. All the details of the pose are seen to be present in the underlying skeleton.

In the skeleton, all the details of the pose and the arrangement of the joints that determine the outline and proportions of the drawing can be clearly seen.

■ The muscles

The study of the musculature of the human body can obviously be carried out on various levels, but from the artistic point of view, special emphasis should be placed on the areas of muscle that most affect the external form. In reality, the contours of the body that we see are the result of the volume of the muscles—even the more internal ones—although obviously the ones just beneath the surface of the skin are the ones of greatest interest to the artist. On these pages we show you a front and back view of the superficial musculature of the human body, indicating the name of each muscle. We have based these diagrams, as with the skeleton, on the pose of Michelangelo's "David." It is important to take note of each of the muscles shown here and to try to identify them in your individual model when drawing from life.

Front view

Head muscles: 1. Frontal. 2. Temporoparietal. 3. Masseter. 4. Orbicularis oris. 5. Triangular of the lips. Platysma.
Neck muscles: 6. Sternomastoid. 7. Sternohyoid muscle. 8. Trapezius.
Thorax muscles: 9. Pectoralis major. 10. Serratus lateralis.
Abdominal muscles: 11. Obliquus abdominis externus. 12. Rectus abdominis. 13. Linea alba.
Arm muscles: 14. Deltoid. 15. Biceps brachii. 16. Triceps brachii. 17. Flexor carpi radialis 18. Brachioradialis.
Leg muscles: 19. Tensor fasciae latae. 20. Sartorius. 21. Quadriceps (rectus femoris). 22. Vastus medialis. 23. Vastus lateralis. 24. Gastrocnemius. 25. Tibialis anterior. 26. Peronaeus longus. 27. Soleus.

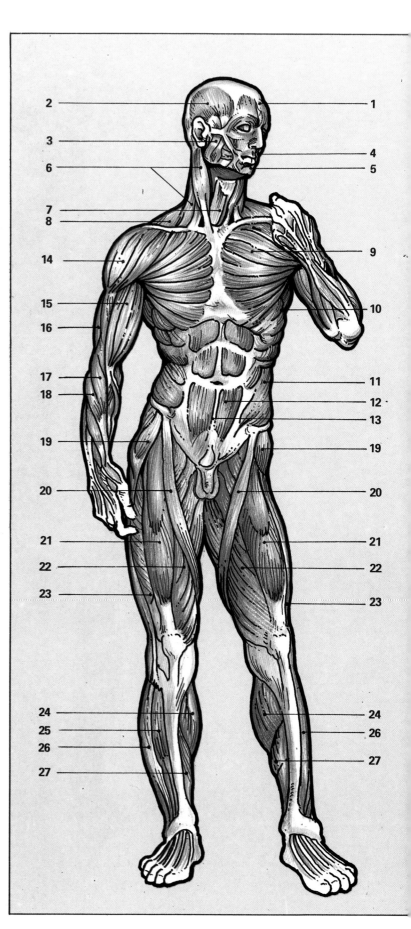

Front view of the superficial muscles of the human body. Try to learn their names in order to identify them in a living model.

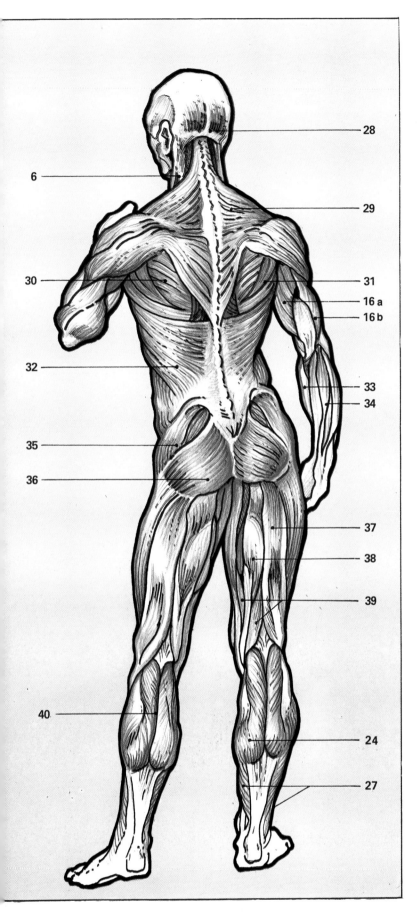

Back view

Head muscles: 28. Occipitalis.
Back muscles: 29. Trapezius. 30. Infraspinatus. 31. Major rhomboid. 32. Latissimus dorsi.
Arm muscles: 16a. Vastus interior triceps brachii. 16b. Vastus exterior triceps brachii. 33. Flexor carpi radialis. 34. Flexor carpi ulnaris.
Leg muscles: 35. Gluteus medialis. 36. Gluteus maximus. 37. Biceps femoris. 38. Semitendinosus. 39. Semimembranosus. 40. Triceps surae. 24. Gastrocnemius. 25. Soleus.

As always happens when one is faced with theory of any kind, questions arise about the practical value of studying it. An understanding of the laws of proportion allows us to calculate the measurements of parts of the body in relation to its overall height, or to the basic unit; obviously, it also gives us a solid base for producing a harmonious and slender figure. A knowledge of its anatomy can also help us to situate each joint and muscle in the right place. Naturally, the musculature of the woman's body is exactly the same as that of a man's. The structural differences that we see between the male and female bodies are because of the different development of certain parts of the skeleton. The woman's pelvis, for instance, is broader than that of the man's. The woman also has a more obvious layer of sub-cutaneous fat than the man, which accounts for the greater softness of the contours of the female body, even in the case of gymnasts and sportspersons. A male gymnast has a more angular body than his female counterpart, even if they have both trained to the same level of fitness.

Back view of the superficial muscles of the human body.

Study of the hands

The expressiveness of the human being (our capacity for expressing feelings and emotions) is mainly transmitted through the facial muscles. However, the eyes are not the only "mirror of the soul," as the saying goes: The hands also have a lot to tell us.

Have you ever analyzed the extraordinary mobility of your own hands? Have you ever watched with curiosity the infinite number of gestures the hands make when we talk to one another, when we are expressing ourselves? All the great artists have understood the expressive potential of the hands and, as a consequence, have carefully studied their anatomical structure and their movements.

Look for examples throughout the history of art, study them attentively and with a certain reverence, and you will be amazed at the beauty and expressive power of this important part of the body.

Drawing a hand (drawing it well, that is) is one of the hardest things an artist has to learn. However, just as with the human face, it is one of the most fascinating subjects there is.

Besides this, it is a subject that is always within reach; if you draw with your right hand, the left is always ready to pose. And of course, the same applies in reverse if you are left handed. So there's no excuse: No one can claim that he doesn't draw hands because a model can't be found. We are going to dedicate the last pages of this book to teaching you how to draw hands... starting with your own!

It is not an easy undertaking, because the hand is not a single form; it is a combination of forms, each capable of independent movement and that we tend to see in acutely foreshortened positions.

The way to resolve the problems arising from this foreshortening effect is to make a thorough analysis of the bone structure of the hand; its joints are the points of reference for calculating all the relevant proportions.

So, prepare yourself—you are going to have to do some hard work.

While one hand is drawing, the other is posing. This is a good way of studying the forms that make up the hand, of getting to know the endless positions it can adopt, and also of acquiring the confidence needed to capture its expressive power.

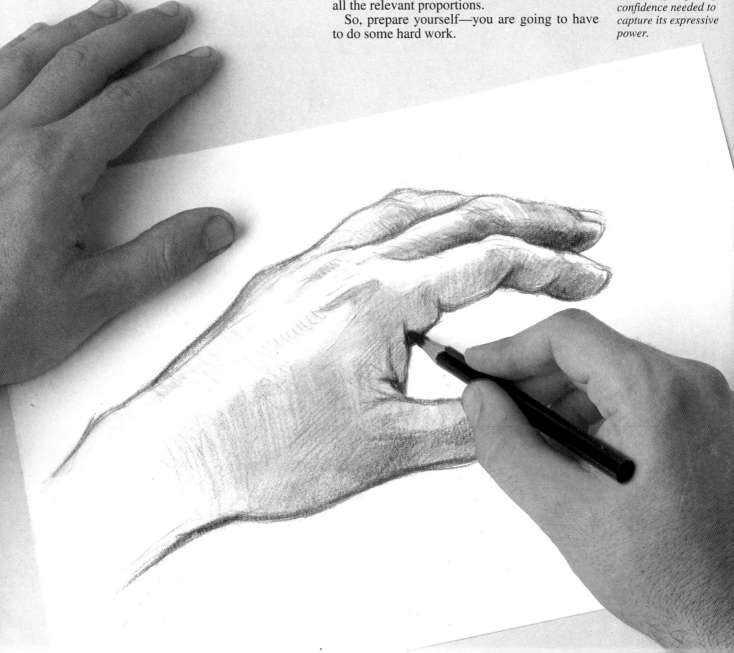

Three examples from old masters

Left. Study of a hand drawn by Bartolomeo Passeritti (1529–1592) with pen and brown ink (Louvre Museum, Paris).

Below, left. Study for the hands of the Virgin and St. Isabel, by Federico Barocci (1528–1612). White and black chalk on blue paper (Staatliche Museum, Berlin).

Below, right. Study of hands by Leonardo da Vinci, in the Royal Library of Windsor Castle. Engraving with highlights on prepared pink paper.

The skeleton

RADIUS

CUBIT

CARPUS
CARPAL BONES

FIRST METACARPAL
SECOND METACARPAL
THIRD METACARPAL

FIRST PHALANX OF THE THUMB
FOURTH METACARPAL
FIFTH METACARPAL
SECOND PHALANX OF THE THUMB
FIRST PHALANX

SECOND PHALANX

THIRD PHALANX

CARPUS EXTERNALLY

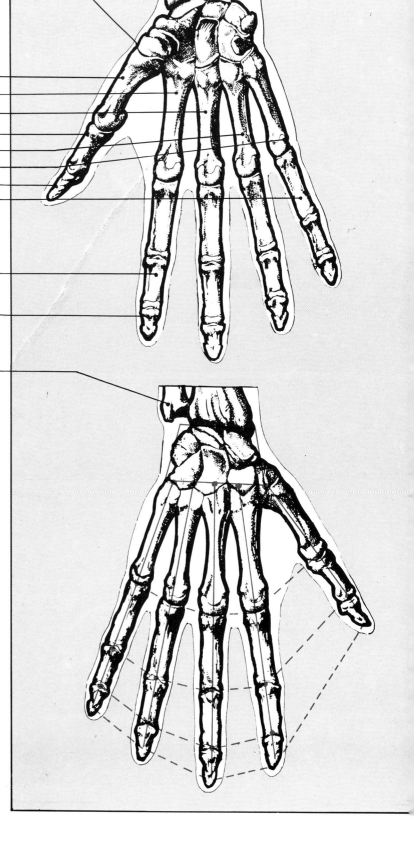

Look at this diagram of the skeleton of the right hand, in the position which, anatomically speaking, is considered normal. Notice that, from the wrist joint, the hand consists of three clearly defined groups of bones. The first group of small bones constitutes the carpal region. From these spring the five elongated bones of the metacarpal region. Finally, there are the finger bones, or phalanges: Two in the thumb and three in the other fingers.

The great mobility of the thumb is worth noting: Man is the only animal that can use it in opposition to the other fingers.

From our point of view as artists, it is important to memorize the linear pattern described by the bone structure of the hand: From the trapezium, or carpal region, a series of five radial lines (centering upon the wrist, more or less) constitute the axes of the five metacarpal bones and the phalanges of the fingers.

If the points marking the joints of these axes are linked, various polygonal shapes are formed that are well worth remembering when we have trouble recollecting the proportions of the hand.

The proportions

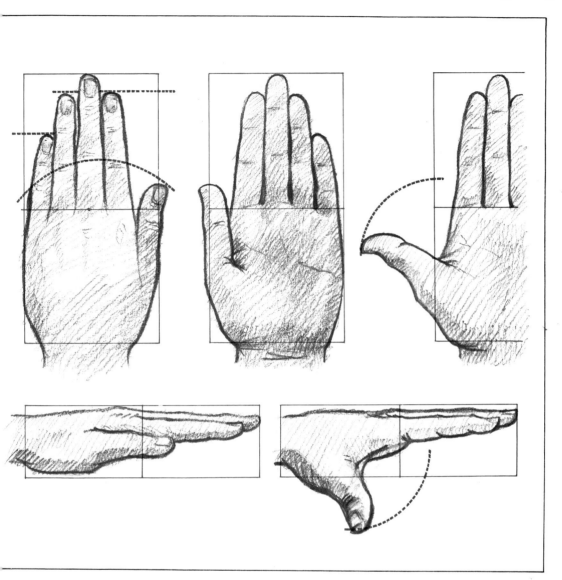

We can establish a rough rule of proportion for the hand, based on two square units that meet at the joints between the metacarpal bones and the first phalanges of the fingers. It is not an exact formula, but it is a guide to the correct proportions of any hand. Notice that each finger is a different length—the differences can be measured approximately in sevenths of a unit. The equal size of the two units is maintained whatever position the hand is in, although they are, of course, seen in perspective. Besides, the second unit (the one containing the fingers) will hardly ever be seen as a single plane. The flexible movement of the fingers will create many individual planes. You have been warned that drawing a hand is not at all easy. So be brave and get drawing right away!

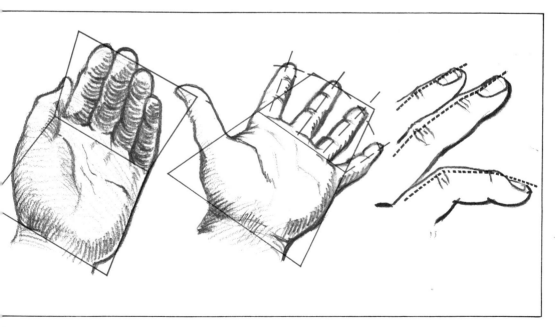

Drawing a hand almost always involves representing the effects of pronounced foreshortening. The joints are a good guide to keeping everything in proportion.

Life drawing exercises

On this page you can see four pencil studies (in 3B and 6B) of a left hand. They show four different poses of the same hand (the left hand of the artist, to be precise) that you should copy, but using your own hand as the model. Notice that in all four drawings, the light is coming from the left, creating quite clearly defined areas of light and shade. Find a light source that does not complicate the drawing, but gives your model a sharp, crisp outline.

Pay attention to the foreshortening of the fingers. Look, for instance, at the ring finger and little finger of the first study and you will see how important the little touches of light are on the fingertips and on the illuminated underside of the little finger. These highlights contribute greatly to the accurate representation of the foreshortening effect.

Notice how the effects of foreshortening can sometimes be resolved by clever use of highlights.

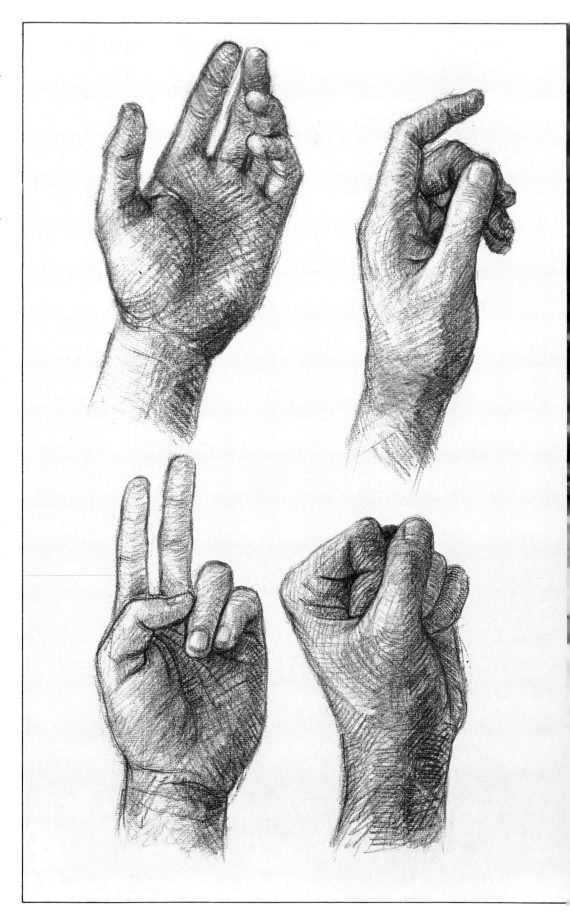

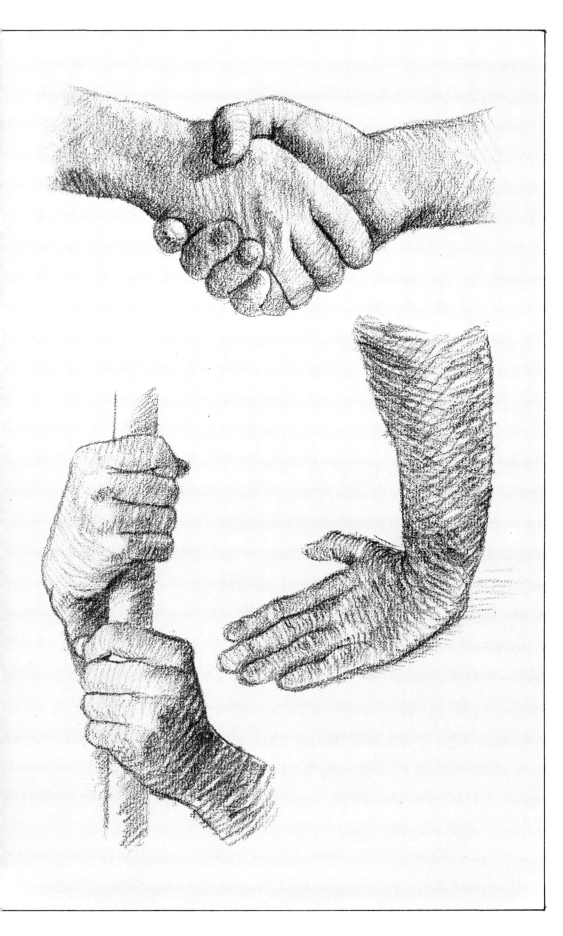

The objective of the studies on the previous page was to catch the hand in a few of its many fleeting poses.

In this next series of studies, the hands are not just being hands; they are in action. Capturing the effort and the muscle tension in the hands is one of the hardest things. Often, the drawing itself can be correct in terms of form and yet be completely devoid of any quality of expression. The strength of these hands (the sensation that they are strong) has been achieved in this drawing in two different ways: First, the structure has been built up through effective use of light and shade (and considerable tonal subtlety); second, the outlines of the forms themselves have been drawn sharply but sensitively. Sometimes, it is useful to form a concept of volume in your drawing and, as in the first and second studies in this series, to contemplate your subject with the mind of a sculptor.

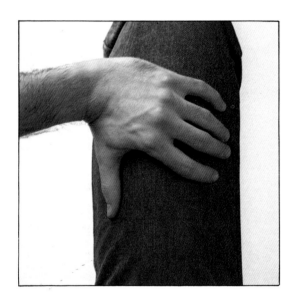

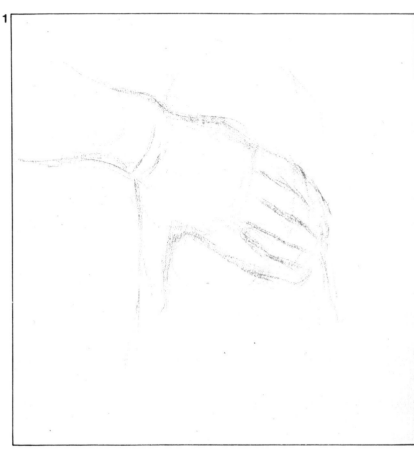

1

Study of the left hand, drawing from life.

Look at the photograph: The artist has rested his left hand on his left leg, so that from above he has a clear, almost frontal view of it. Now do the same, or the opposite if you are left handed. The steps to follow are the same as with any other drawing:

1. With faint lines, draw an outline sketch; you will probably find that the observations made on pages 118 and 119 pay dividends at this point.

2. Once you are happy with the initial sketch, build up the outlines and indicate the main areas of shading (on the fingers and the arm) to create an early sensation of depth. Look closely at the fingers and you will see that the light has created some distinct areas of tone: A darker area around the second and third phalanges of the index and middle fingers, medium tone on the ring and little fingers, and another kind of medium tone on the first phalanges of these same fingers. Defining the upper end of this last plane, a distinctive shadow is caused by the knuckle joints where the first phalanges meet their corresponding metacarpal bones. Finally, the thumb and the contours of the upper palm constitute yet another completely different plane.

2

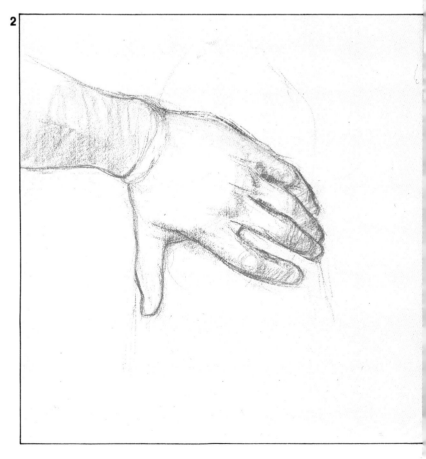

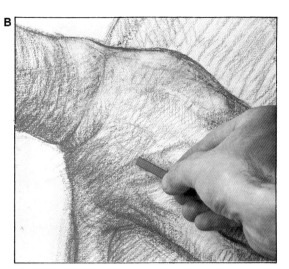

Close-up A.
Emphasizing the contours, using line to define volume, that is, to distinguish between the finger itself and the surface it is resting on (the leg).
These lines must have a little "life:" Make sure that they vary in thickness and intensity.

Close-up B.
Building up contours with a sanguine crayon. Part of the "personality" of a hand lies in the greater or lesser prominence of the veins on the surface of the upper palm.

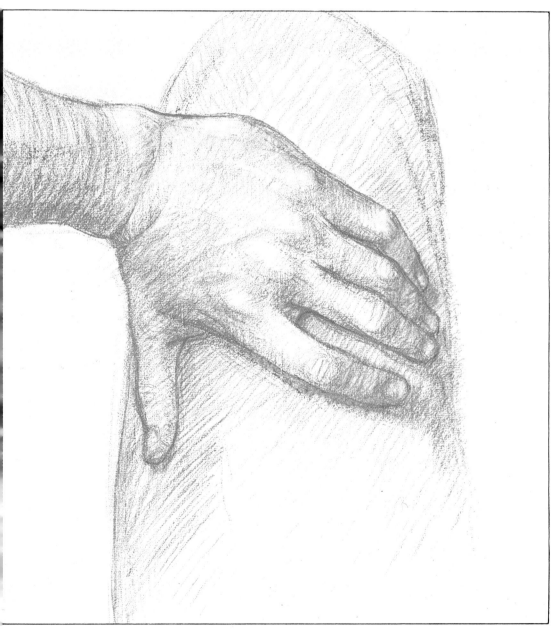

3. Build up the tone from the main areas established during stage 2. Study carefully the contours and hollows caused by the anatomical elements beneath the skin: The knuckle joints, the tendons, and veins that, in an adult's hand, can be tremendously expressive. The objective is to achieve, as our artist has done, an image that is a faithful representation of nature, but without lapsing into a labored kind of realism. It is possible to convey the texture of the skin lying on top of certain internal forms, without having to go into minute detail.